C000104506

HAWORTH
THROUGH TIME

Steven Wood *&* Ian Palmer

AMBERLEY PUBLISHING

Acknowledgements

I would like to thank the following who have helped with finding old photographs and b providing information about them:

Eric Bates, Michael Baumber, Bradford Central Library, Robert Buckley, The Civic Trust, Malcol Craven, Shirley Davids, Molly Davidson, Ann Dinsdale, Anne Dransfield, Edinburgh Woolle Mills, the late Edward Fearnside (who would have enjoyed this book), Robin Greenwood, Mar Hatchard, Janet Holdsworth, the late Harold Horsman, Steve Hume, Keighley Local Studi Library, John & Barbara Laycock, the late Jack Laycock, Ronnie Mace, Wendy Myers, Bill Ada Parker, the late Mary Preston, Michael Smith, Peter Snaith, the late Michael Snowden, Er Stoney, Flossie Waddington, Stephen Whitehead, the members of WR 28 HG – and all the othe who have helped over the years.

First published 2009

Amberley Publishing
The Hill, Stroud
Gloucestershire, GL5 4EP

www.amberleybooks.com

Copyright © Steven Wood & Ian Palmer, 2009

The right of Steven Wood & Ian Palmer to be identified
as the Authors of this work has been asserted in accordance
with the Copyrights, Designs and Patents Act 1988.

All rights reserved. No part of this book may be reprinted
or reproduced or utilised in any form or by any electronic,
mechanical or other means, now known or hereafter invented,
including photocopying and recording, or in any information
storage or retrieval system, without the permission in writing
from the Publishers.

British Library Cataloguing in Publication Data.
A catalogue record for this book is available from the British Library.

ISBN 978 1 84868 509 3

Typesetting and Origination by Amberley Publishing.
Printed in Great Britain.

Introduction

Haworth is famed mostly for the Brontë family. They were here for 40 years but the village has probably been here for a thousand years. It is a Pennine village which made its living from farming, stone quarrying and textile manufacture. Because of the interest in the Brontës it has been more photographed than most small towns but the photographs have mostly been of the church and parsonage. I have tried to bring together a selection of old photographs (from the 1860s to the 1970s) which give a more representative picture of the place.

Change over the centuries has been brought by a number of factors. The making of the Blue Bell Turnpike through Haworth in 1755 probably caused the initial development of Main Street and linked the settlements of Hall Green at the bottom and Haworth at the top. There are a great many non-conformist chapels in the Haworth area, partly because William Grimshaw, one of the leaders of the evangelical revival of the eighteenth century, was minister here.

A second turnpike road was built in 1814 from Lees to Hebden Bridge; this later formed the upper limit of development on Haworth Brow. The first gas works was built in 1857. The opening of a branch railway from Keighley in 1867 must have given an impetus to trade and started a major expansion of the village in the later nineteenth century. It also necessitated a number of changes in the roads serving the lower part of the village. In the 1870s several large reservoirs were constructed in the upper Worth Valley to supply Keighley and Bradford with water. The effect of these was mostly felt by the farmers although it had implications for the mills as well. The collapse of the Yorkshire Dales lead mining industry and a widespread agricultural depression elsewhere brought many families into the area in the 1880s and 1890s.

The first half of the twentieth century saw some new housing built, streets widened and roads surfaced with tarmac. Electricity began to replace gas, at least for lighting, in the 1930s.

The pace of change accelerated in the second half of the twentieth century. Two large areas of older housing were demolished in the name of slum clearance. A new road bypassed Main Street and the Mytholmes route from Haworth to Oakworth was greatly improved.

Indeed the growth in ownership of cars has been one of the most potent causes of change. The railway closed but was soon re-opened by a preservation society. The quarries worked more sporadically and eventually all but one closed. The textile mills closed one by one until today only a single mill still produces specialist narrow fabrics. The smaller farms went out of business until now all the agriculture is concentrated in a small number of larger farms.

As the industry died out Haworth became a more desirable place to live. More and more people travelled out of the village to work in Keighley and Bradford. There have been large new housing developments over the past few decades to meet the needs of incomers and smaller families. With the advent of supermarkets in neighbouring large towns people now do most of their shopping elsewhere and local shops have closed. Many of those which survive now cater for tourists rather than residents.

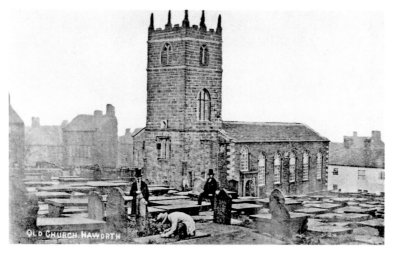

Old Church, 1860s
Note the rather lopsided looking building to the left of the church tower. This stood in what is now Church Street. It was bought by the church and demolished in 1870 and the lane was diverted away from the church buildings.

I hope that these photographs will illustrate at least some of the trends which have changed *Haworth Through Time*.
I should add a note about the new photographs. Ian Palmer has taken great pains to reproduce the views in the old pictures but this has not always been possible. New buildings and the growth of trees were significant problems. Traffic was a constant difficulty got over only with much patience – and some daring! New street furniture has made many of Ian's photographs less pleasing than they might have been but the old photographs, rather than aesthetic considerations, dictated what had to be taken.

Steven Wood
Haworth

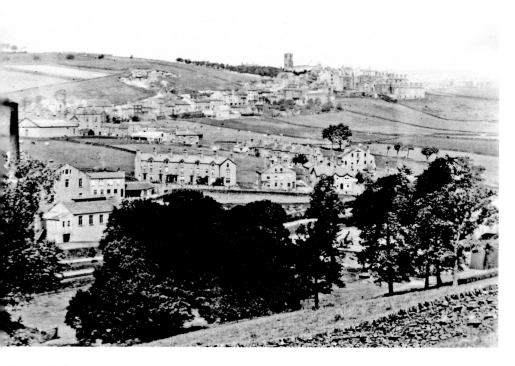

Haworth from Brow, 1880s

Ivy Bank mill with its smoking chimney is visible on the left – it is now a burnt out ruin and the chimney has gone. The six houses on Ivy Bank Lane are prominent and date this picture to before 1890 when the other six were built. The increase in late nineteenth century housing for mill workers is obvious from these photographs – as is the surprising number of new trees in and around the village.

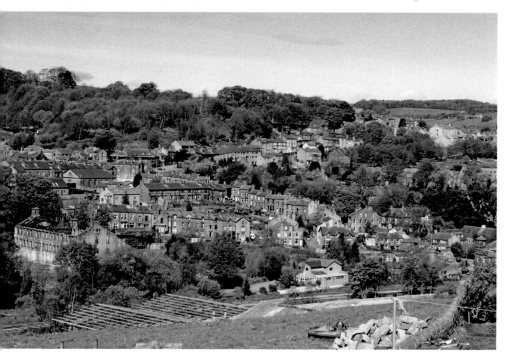

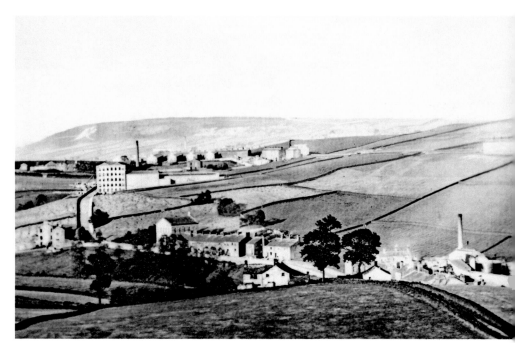

Haworth Brow, c. 1880

The extent of late nineteenth-century building is well seen in these general views of Haworth Brow. The Brow developed in the 1880s and 1890s and attracted immigrant workers from Swaledale where the lead mines were closing and from Wiltshire which was suffering from the agricultural recession. The chimney on the right belongs to the 1857 Haworth gas works.

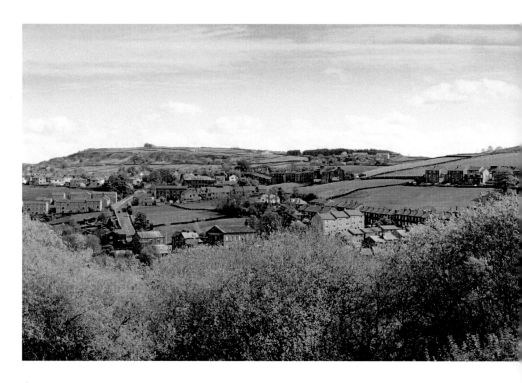

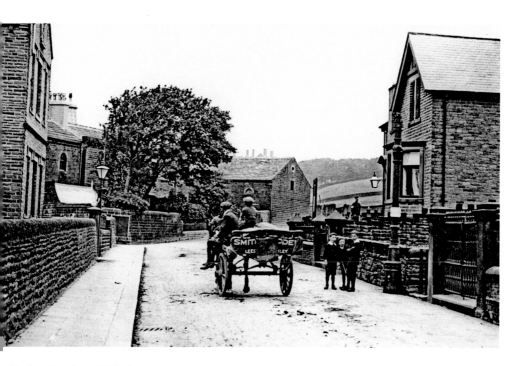

Police Station, Mill Hey, c. 1910

Haworth's police station and masonic lodge face each other across Mill Hey. They were both built in 1907. A police officer can be seen in our old photograph and Jens Hislop, a retired police officer who now owns the old police station, in the new picture. Ebor House, which is largely obscured by a tree, was the mill owner's house for Ebor Mill. Just visible in the distance is Longlands – Haworth's Youth Hostel.

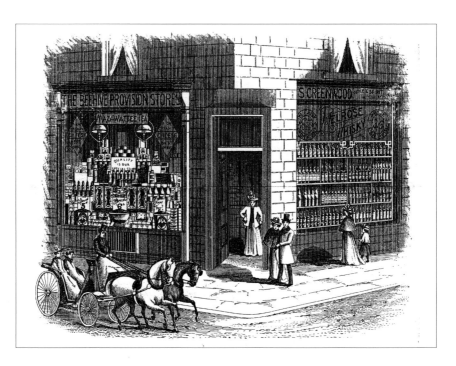

Beehive Stores, Mill Hey, c. 1900

Stephen Greenwood advertised his Beehive Grocery Stores in one of the first tourist guide books to Haworth published by local printer A.E. Hall in the early years of the twentieth century. The disproportionately small figures serve to give prominence to this small shop. Mazawattee tea is heavily advertised here – as it is in early photographs of the shop. Greenwood was here until about 1936 when he retired to Blackpool.

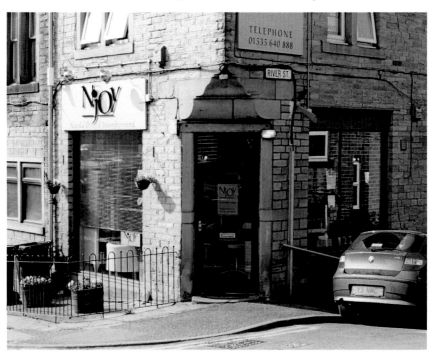

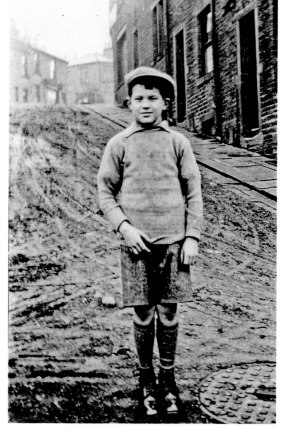

River Street, c. 1929

A young Arthur Holdsworth stands on River Street in the late 1920s. He was a member of a well known family of Haworth butchers. The distinguished historian Asa Briggs remembers him as the cleverest boy at Keighley Boys' Grammar School. Arthur left at 15 to join the family business. After his retirement he earned a first in mathematics from the Open University. He died shortly before this photograph of his daughter Janet was taken in 2009.

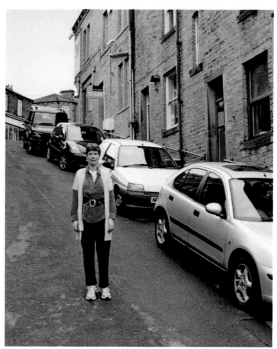

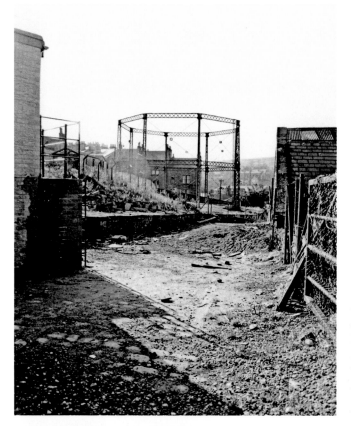

Gas Works, 1976

Haworth Gas Company built their works on this site in 1857. They were acquired by the Haworth Local Board in 1871 and later rebuilt. Gas was last made here in 1954 when Haworth gas works became a distribution centre for gas piped up from Keighley. The works were finally closed in 1972 with the advent of natural gas. Our photographs show the site before and after it was cleared to make a car park.

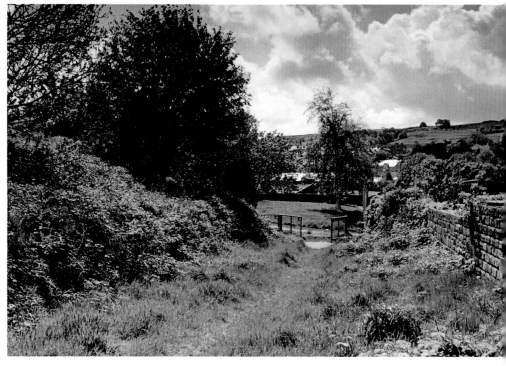

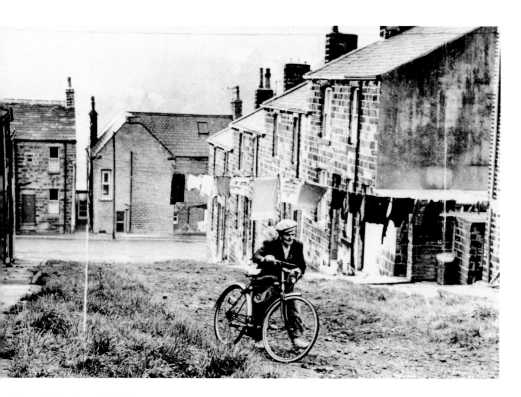

Dean Street, c. 1970

Here we see local builder Tom Laycock pushing his bicycle (his only form of transport) up Dean Street on the way to a job. The streets of the Brow climb steeply up the valley side. Many of them were never surfaced for cars and are now attractively grassed over. Other changes of the past forty years are visible: cars for bicycles, wheelie bins for dustbins and satellite dishes instead of TV aerials. Washing lines survive unaffected.

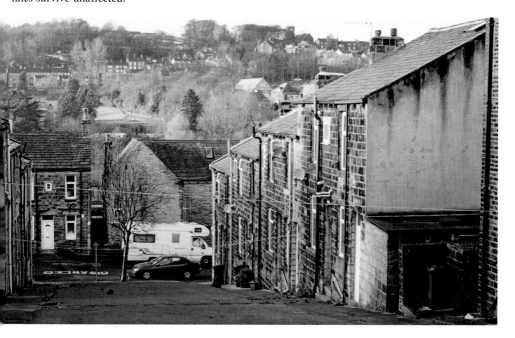

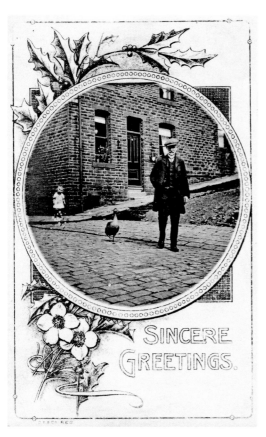

SINCERE
GREETINGS.

May Street, 1920s

An earlier street scene on the Brow. In the 1920s Prince Street was surfaced with setts (probably from Dimples Quarry) and May Street was unsurfaced. Both are now tarmacadamed. William Smith was described in the 1901 census as a 44 year old warp dresser. He lived at the corner house behind him in this photograph. His reasons for keeping a pet goose remain obscure.

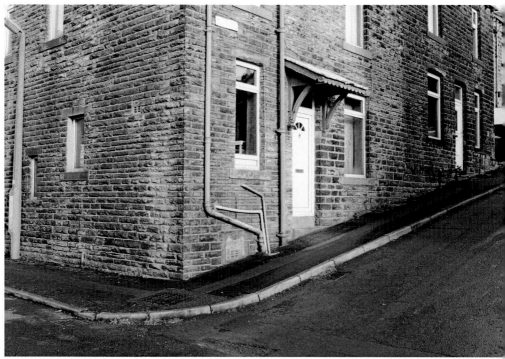

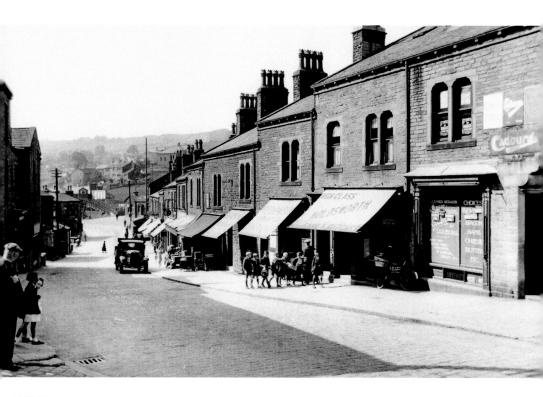

Mill Hey, 1930s

A view along Mill Hey from the top of River Street to the Railway Station shows a dozen or so shops serving Haworth Brow. In this photograph there were: a grocer, butcher, printer, provision merchant, furniture dealer, fruiterer, two tailors, a chemist, a dairyman and a confectioner. Mill Hey is still better provided with useful shops for residents than any other part of Haworth.

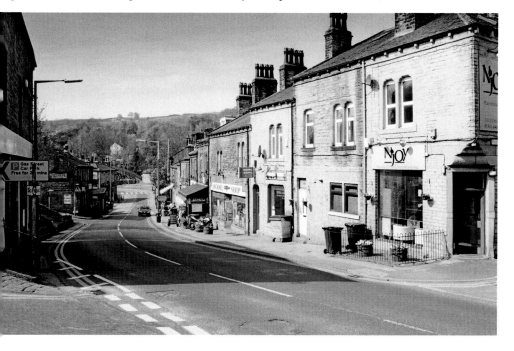

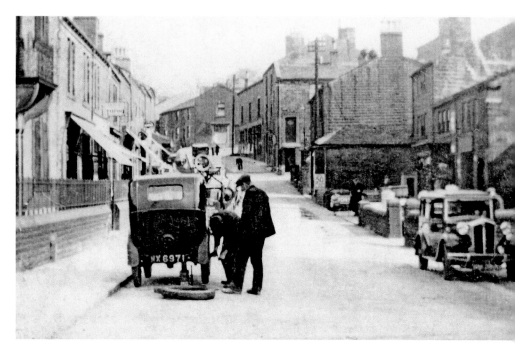

Mill Hey, 1930s

Here we have the same stretch of Mill Hey as in the previous photograph but looking back towards Lees. There were, and still are, fewer shops on the right hand side of the road but they include the Haworth Brow Post Office – as important then as it is today. Standing by the man changing his car wheel is Teddy Fearnside.

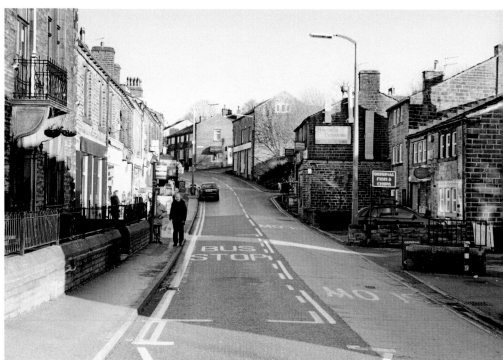

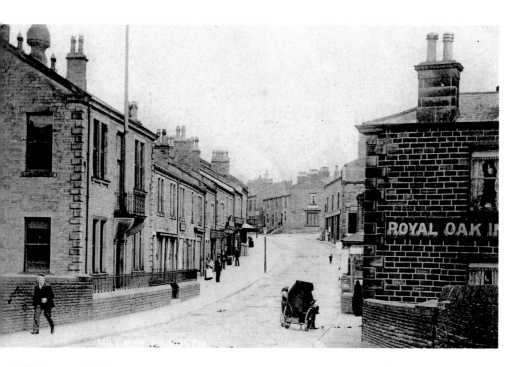

Mill Hey, c. 1910

A rather earlier view of Mill Hey taken from Mill Bridge. Prominent on the left is the Conservative Club which opened here in 1889 having moved from smaller premises in a cottage on West Lane. The Royal Oak, rather surprisingly, pre-dates the railway, first appearing in the trade directories in 1854. A few doors up from the Conservative Club you can see the barber's pole on John Baldwin's shop.

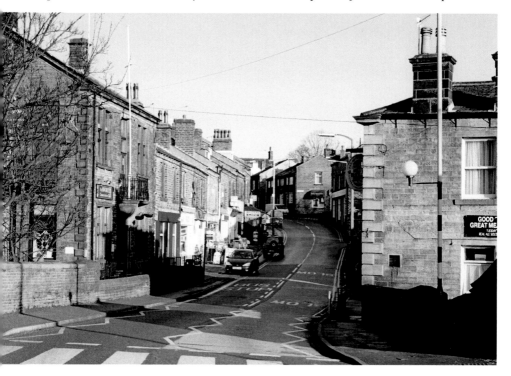

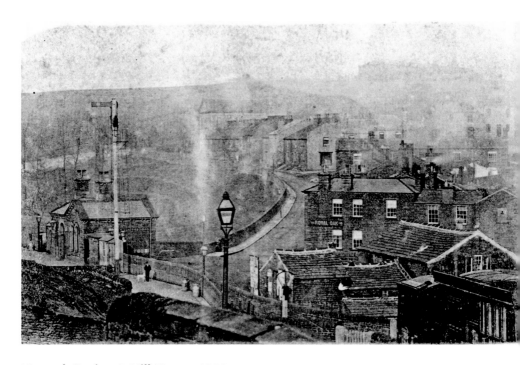

Haworth Station & Mill Hey, c. 1880

Mill Hey before any of the shops and houses on the left hand side were built. The railway station building is the 1867 original, it was later doubled in size. The large stone building behind the wooden cabin (front right) is Haworth's corn mill which is known to have been on this site since the fourteenth century. This is, of course, a much later building.

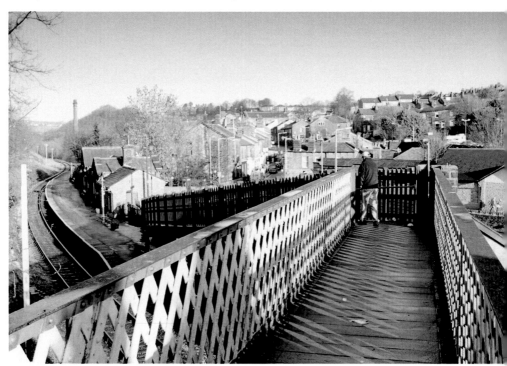

Haworth Station forecourt shops, c. 1972

Very few photographs survive of this row of lock-up shops round the end of the corn mill. They were built in 1925, originally planned to comprise a bank, four shops, a bakehouse and a store room. The Corner Café was advertising in the railway's magazine until 1972. Shortly after this the shops were bought by the railway and demolished along with the corn mill.

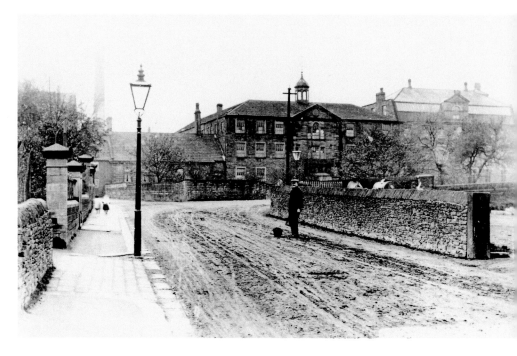

Station Road & Bridgehouse Mills, c. 1910

Station Road was built in 1866-7 for the railway. From left to right are the Bridgehouse Chapel gates, Bridgehouse (1746), the mill buildings and the railway yard. The state of the road gives ample evidence of the horse drawn transport which took goods to and from the railway. The man standing in the road with a bucket at his feet is presumably intent on getting some free fertiliser for his garden or allotment.

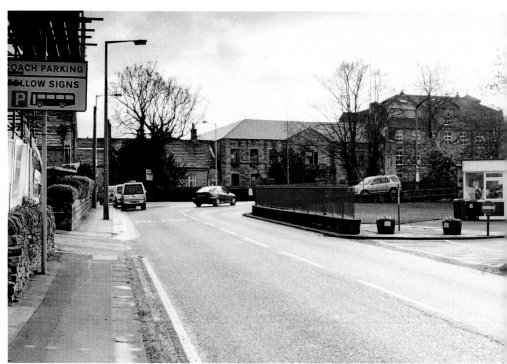

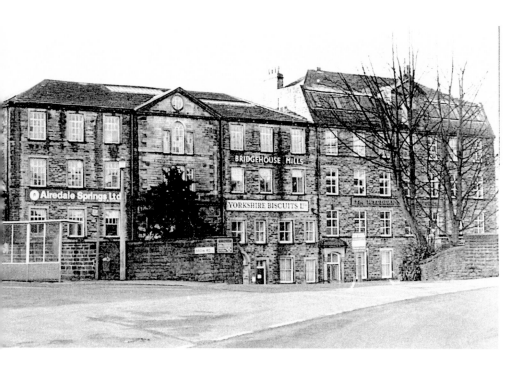

Bridgehouse Mills, 1976

The older mill building on the left is often said to be of the late eighteenth century but was in fact built after 1850, perhaps incorporating parts of an earlier building on the site. It lost its top storey to fire in 2001. The newer spinning mill to the right was built after the railway had diverted the stream – perhaps by Butterfield around 1870. Worsted manufacture stopped in 1974 but narrow fabrics are still produced here.

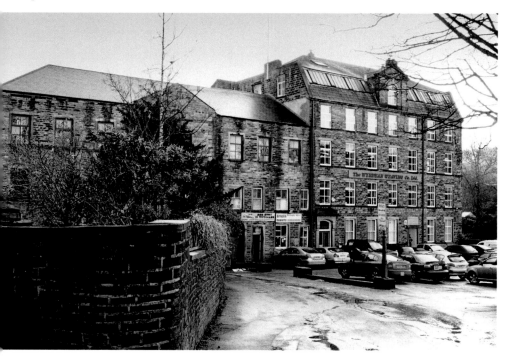

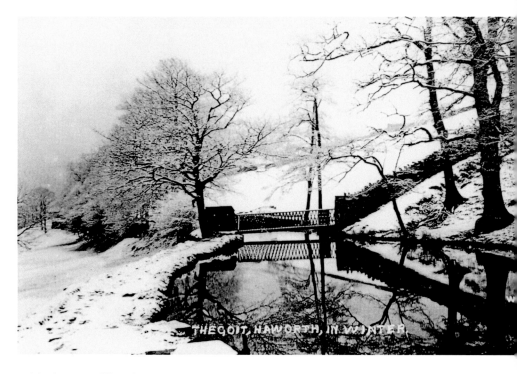

THE GOIT, HAWORTH, IN WINTER

Bridgehouse Mill Goit, 1905

Bridgehouse Mill was water powered for much of its history and a large water wheel survived, as a supplement to steam power, into the early twentieth century. To provide water for the wheel this half mile long goit was constructed around 1811. It runs through picturesque farm land in the valley of the Bridgehouse Beck and became a popular place of resort. It was a favourite subject for photographers who sometimes captioned their cards "Bonny Goit Side".

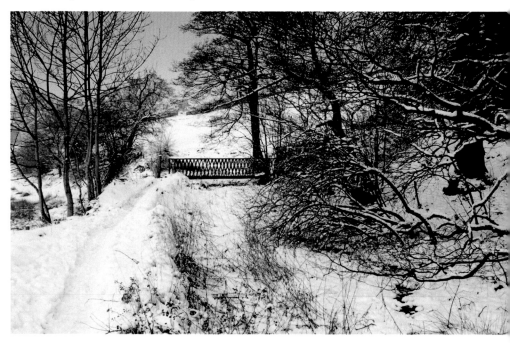

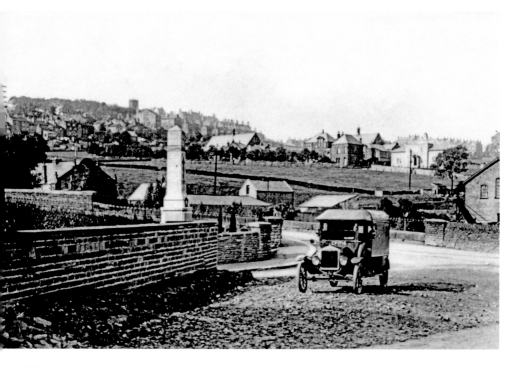

Bridgehouse & Haworth War Memorial, c. 1925

Haworth's War Memorial was dedicated in 1923 and this picture was taken not many years after. Across the fields which now form part of the park can be seen the Board School buildings and the very new looking Haworth Institute of 1924. This was the successor to the old Haworth Mechanics' Institute which closed about this time (see page 64).

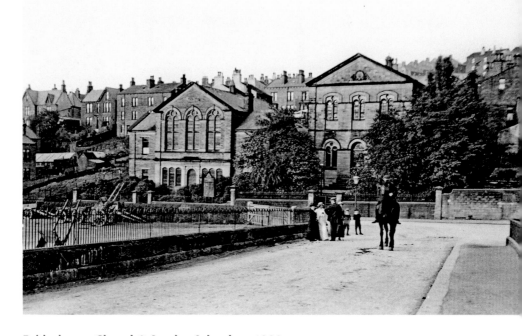

Bridgehouse Chapel & Sunday School, c. 1900

The Bridgehouse Wesleyan Chapel was opened in 1884 as a memorial to Richard Shackleton Butterfield who had owned the nearby mill. The chapel was enlarged and the Sunday School (on the left) was added in 1892. The chapel was demolished in 1964 but the Sunday School building, which was used as an employment exchange, survived into the 1970s. The site is now occupied by apartments for the elderly.

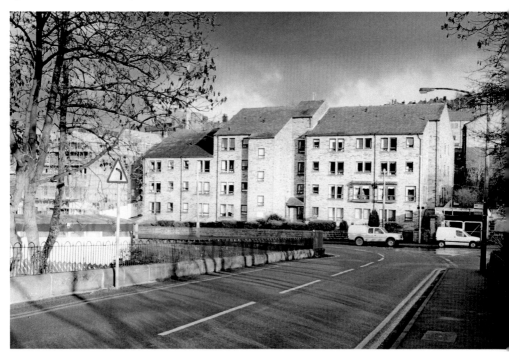

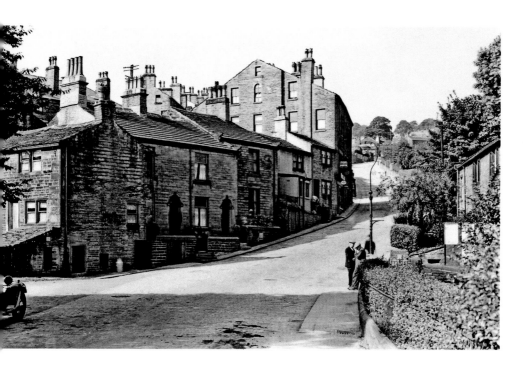

Bridgehouse Lane, 1930s

Mid-nineteenth-century houses dominate the lower part of Bridgehouse Lane with buildings from the second half of that century further up the road. In this view of the 1930s the road is still cobbled and the setts survived until the 1980s when they were badly damaged by a flash flood. They were the last setts on the road through Haworth towards Colne and the chance to surface the road with tarmacadam was taken.

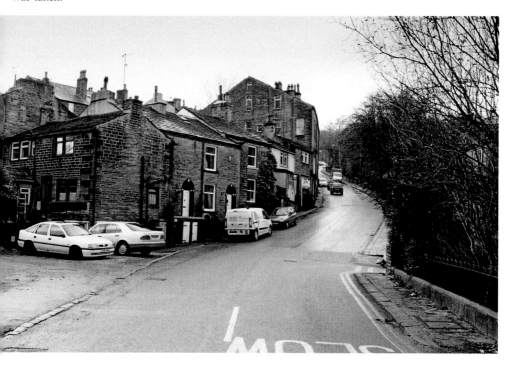

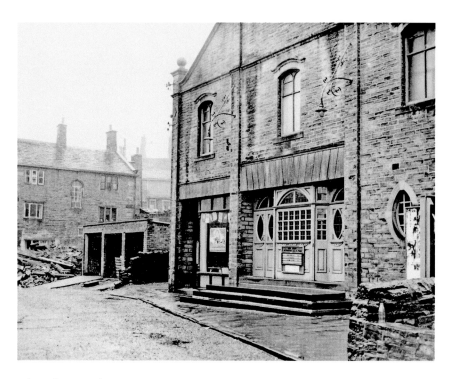

Hippodrome Cinema, 1961

The Hippodrome was Haworth's first cinema and it opened in 1913. After the Brontë Cinema opened on the Brow in the early twenties the Hippodrome was always referred to as "t'owd 'uns", the more recent cinema, naturally, being called "t'new 'uns". The last film *Trooper Hook* was shown in 1961. After that the building was used as a bingo hall, then as a 'Bygone Days' museum. It is now converted into apartments.

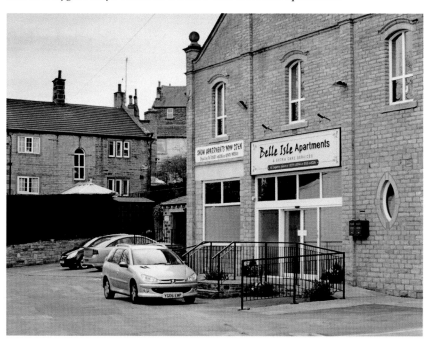

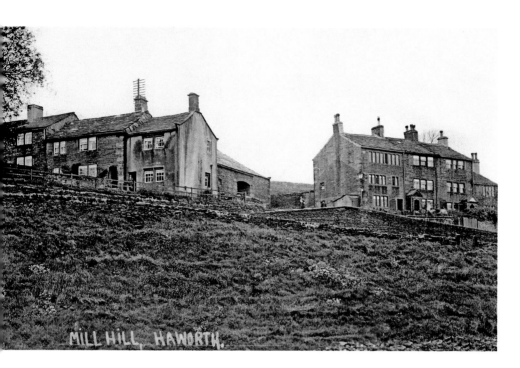

MILL HILL, HAWORTH.

Mill Hill, c. 1890

Lower Mill Hill Farm was occupied by the Magson family who ran the nearby corn mill. The farm survives although it is much altered. The barn attached to the farm must have been demolished over 100 years ago. Butt Lane now runs through the site of the barn. This probably happened when the Board School was built in 1896 blocking the former line of the lane. The cottages on the right are little altered.

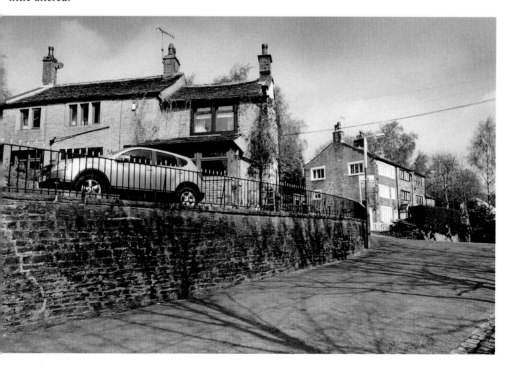

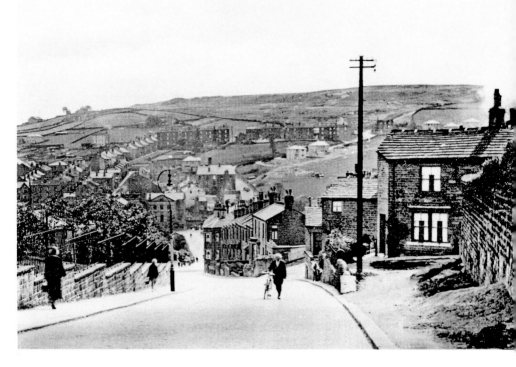

Bridgehouse Lane, 1930s

Looking down Bridgehouse Lane the wall of Hall Green burial ground is on the right and the park wall on the left with its railings intact in this pre-war view. Just beyond the cemetery wall is the end of a terraced row which was knocked down in the 1980s. In the distance new houses are being built on Brow Road and recently completed semis can just be seen on Hebden Road.

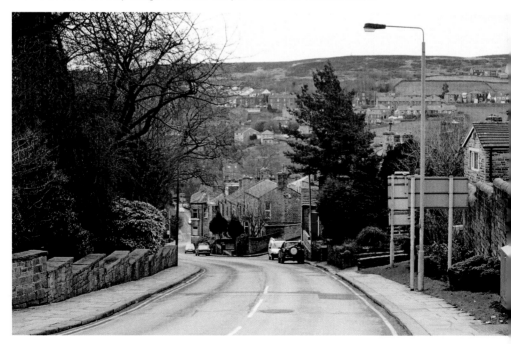

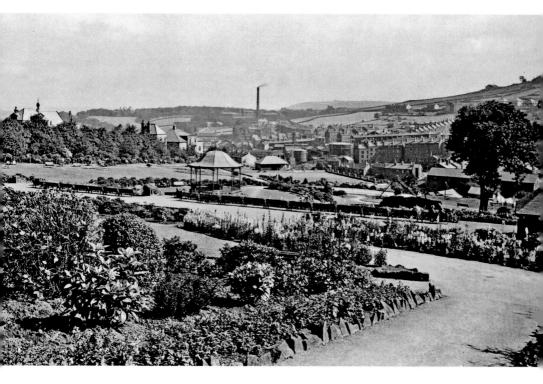

Haworth Park, c. 1940

This general view across Haworth Central Park which opened in 1929 also includes the bowling green which commemorates the Coronation of George VI in 1937. The mill chimney in the distance belonged to Lees Syke Mill which has now been largely demolished to make way for houses.

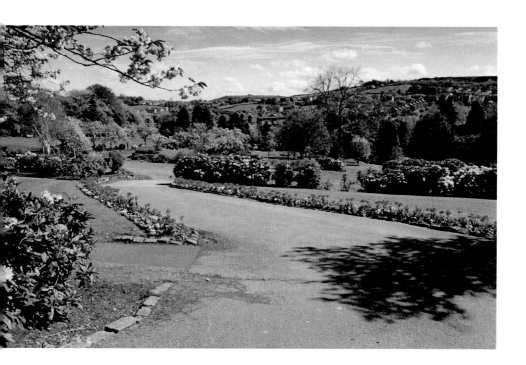

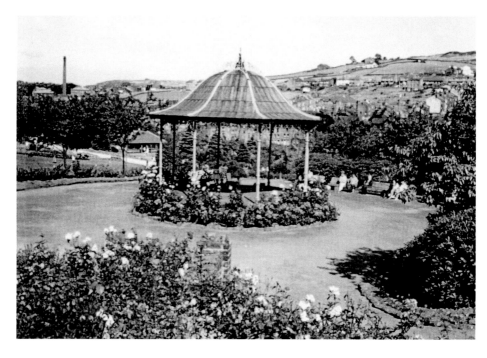

Haworth Park, Bandstand, c. 1960

The bandstand was a central feature of the park for decades, seeing regular performances by the Haworth Band which dates back to the 1860s. It was also used for local events such as the crowning of the Gala Queen. The bandstand was removed many years ago but the Friends of Haworth Park have its replacement as one of their main objectives.

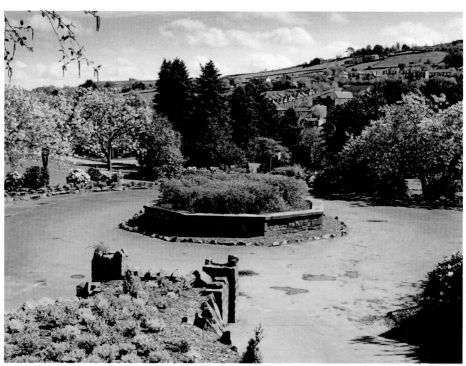

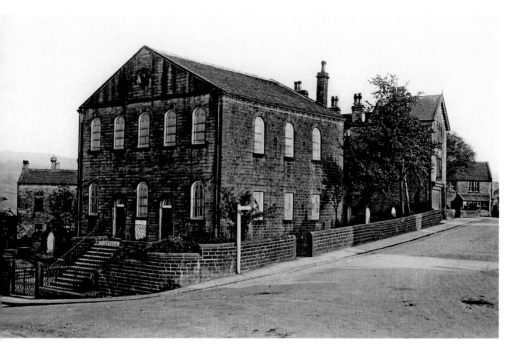

Hall Green Chapel, c. 1910

Hall Green Baptist Chapel is the oldest surviving place of worship in Haworth having been built in 1824. It had its origins in a secession from the West Lane Baptist Chapel over music some years before. Visible in the distance (extreme right) is Sun Street Stores which was started as a grocery shop by Tobias Lambert almost 200 years ago and is still fulfilling the same function today.

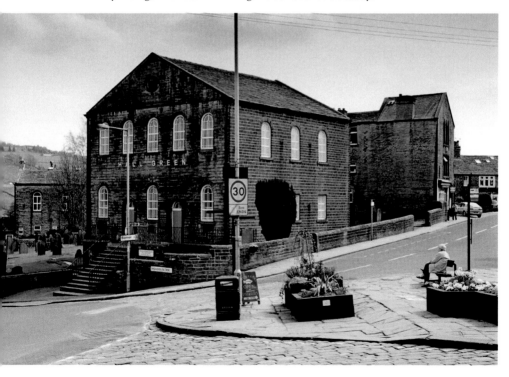

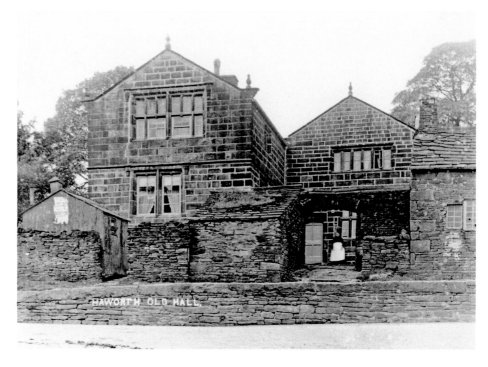

Haworth Old Hall, 1900

One of Haworth's few seventeenth century buildings, the Old Hall was built about 1620 by the Scotts. It is sometimes called Emmott Old Hall but the Emmott family did not build it and never lived there – they bought it from the Ramsdens in 1749. It was still a farm in the nineteenth century but had become rather run down by the mid-twentieth century. In the past thirty years it has been extensively renovated and is now a hotel.

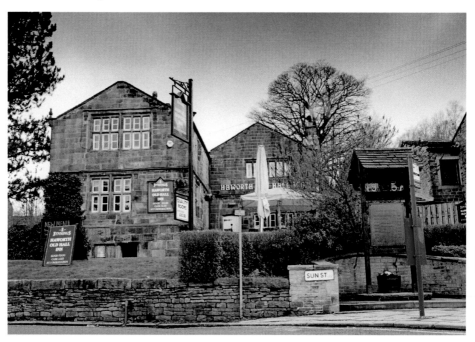

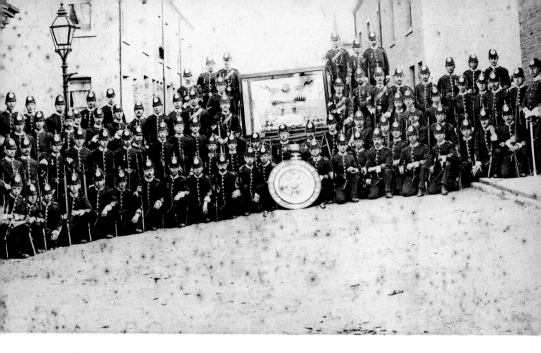

Haworth Rifle Volunteers, late 1800s

The Haworth Rifle Volunteers were formed in 1866 and the Drill Hall on Minnie Street (just visible front left) was built in 1873. They held a bazaar in 1870 to raise money for the building and by the efforts of 'a numerous staff of young ladies who rendered most efficient service' they made £660 – virtually the whole amount required – at this single event. The trophies reflect their extraordinary success in shooting competitions. Our new photograph features members of the WR 28 HG (Haworth Home Guard) re-enactment group.

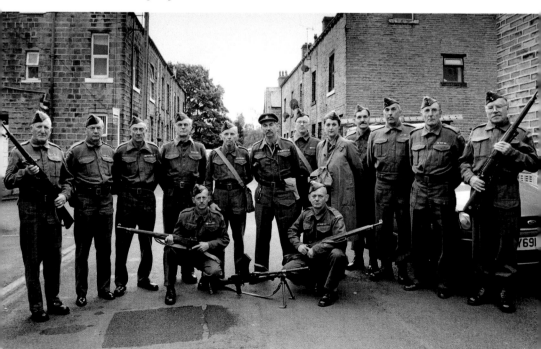

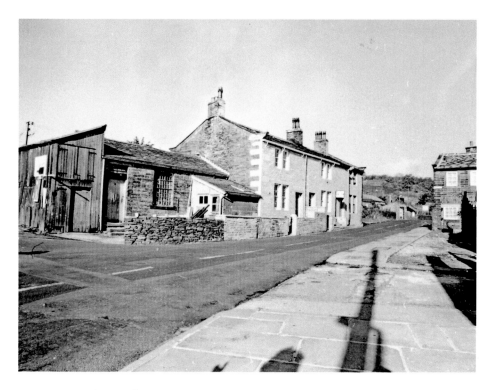

Sun Street, Joiner's Shop, 1976

Robert Ratcliffe started his joinery shop on Stubbing Lane (now known as Sun Street) in the 1860s. Joiners continued to work in these premises until a few years ago. There is now a new detached house where the wood yard stood and the workshop is a 'nail bar'. Adjoining the workshops are three mid nineteenth century cottages, in the distance are the wooden buildings of a co-op grocery shop and the British Legion.

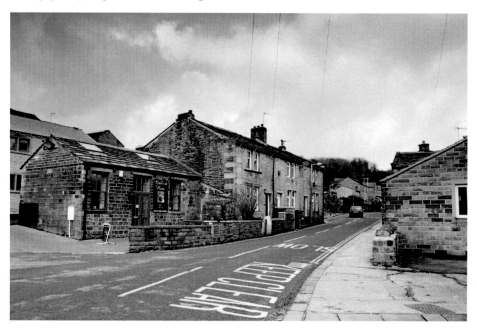

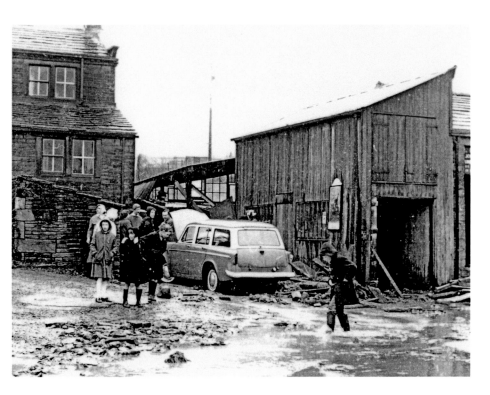

Sun Steet, after flood, 1966

In 1966 the Hough Reservoir burst sending over half a million gallons of water pouring down the fields and into Sun Street. A few houses suffered flood damage but nobody was hurt. This is Ratcliffe's wood yard and saw shed in the aftermath of the flood. The one storey lean-to on the cottage at the left is thought to have been a wool combing shop.

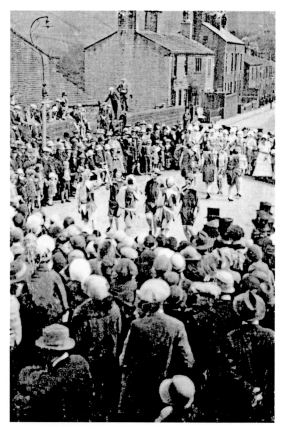

'Morris Dancers', Sun Street, 1920s
There are many photographs of the young people of Haworth in various types of costume for the Parish Church's May Day celebrations. None is more delightful than this view of a group of girls in jesters' outfits doing a dance inspired by the Morris. Other groups in costume can be spotted amongst the numerous audience. Quite where the original photographer took this from is uncertain – we never managed to find the place!

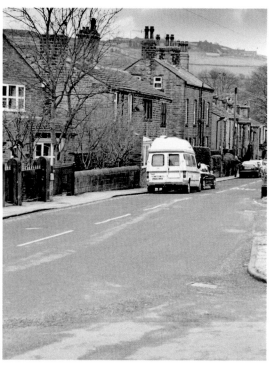

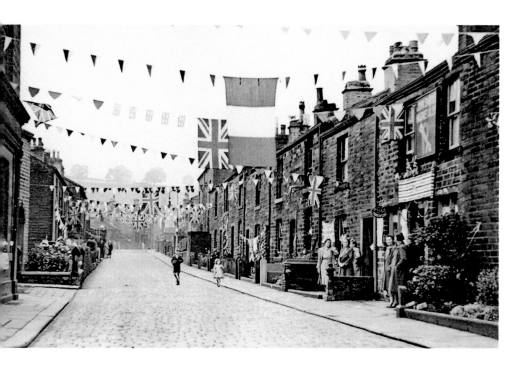

Sun Street, VE Day Celebrations, 1945

Sun Street in celebratory mood again – this time for the end of the war in Europe. Note that the street is still cobbled and that there is an off license shop on the right. The ashlar fronted building on the left is often taken for a branch of the co-op but it seems to have been built around 1854 for Joseph and Joshua Reddiough. These brothers were respectively tailor and boot maker.

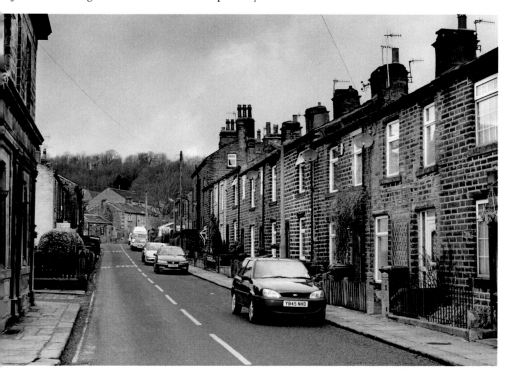

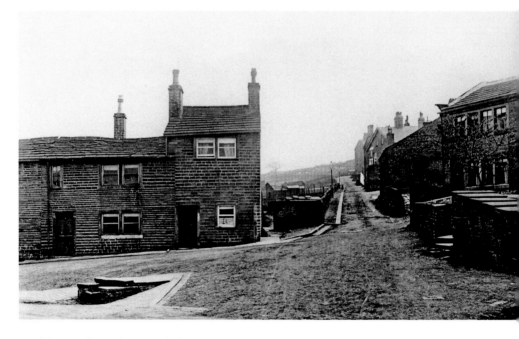

Ducking Well, early twentieth century

These two views show many of the changes which have taken place since 1900. The Ducking Stool has gone, Cold Street has been widened and surfaced, gas lamps have given way to electricity. The allotments on the left side of Cold Street have all been built over. The cars are not the only sign of the dramatic increase in car ownership – what was a tripe boiling shed is now the white garage workshop.

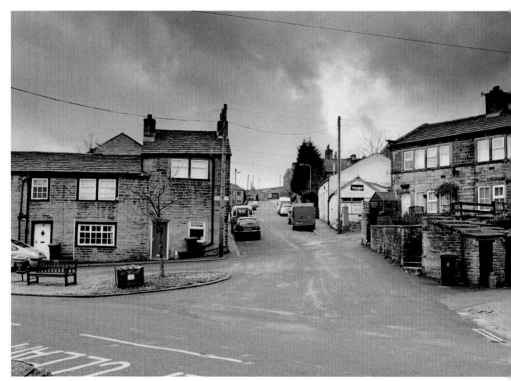

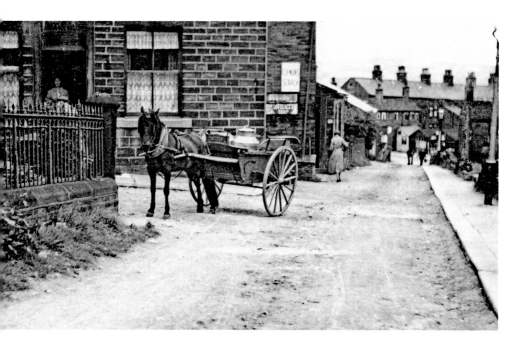

Cold Street, c. 1930

In the 1930s small groups of workers' housing like Coldshaw still had their own corner shop and milk was still delivered by horse and cart. Opposite the bottom of Cold Street can be seen two of a row of wooden lock-up shops on Sun Street. These two were a fish & chip shop and a pie & peas shop. The others were a sweet shop, an outfitter's and a butcher's.

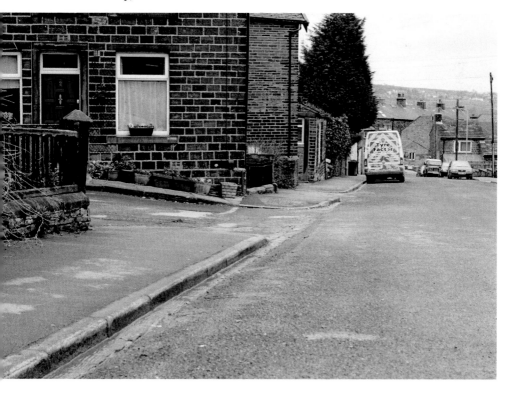

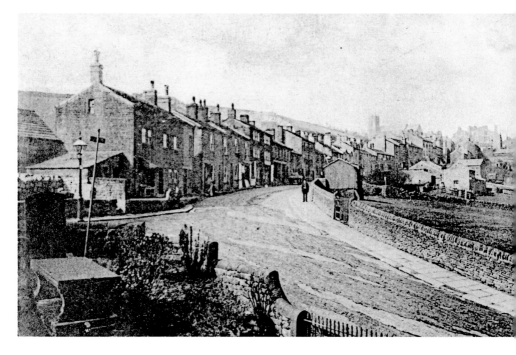

Main Street, c. 1895

The only known photograph of the bottom of Main Street before houses were built on the right hand side. Bar Field which comes right up to the bottom of the street was farmed as pasture by Alexander Dyson of the Old Hall. This picture also pre-dates the building of the 1897 co-op. The houses and much smaller co-op which stood there previously can be seen on the left side of Main Street.

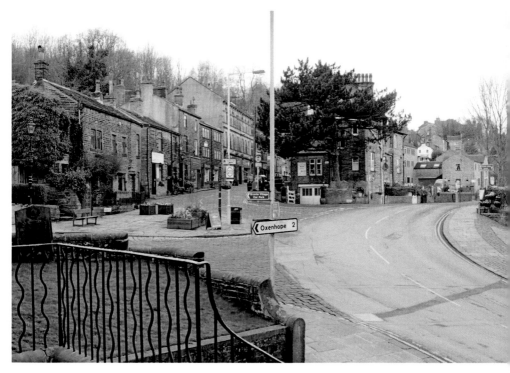

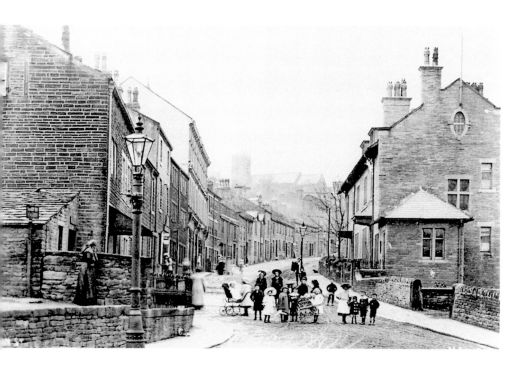

Main Street, c. 1910

A little later the bottom of Main Street has assumed a much more familiar look. The large house and office of William Henry Ogden who was Haworth's Registrar for many years is now prominent on the right hand side of the street, it was built in 1902. The 1897 co-op stands a full storey higher than its neighbours on the other side of the street. The church is clearly visible at the top of the street.

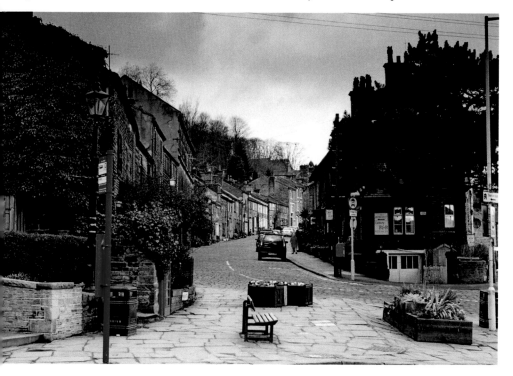

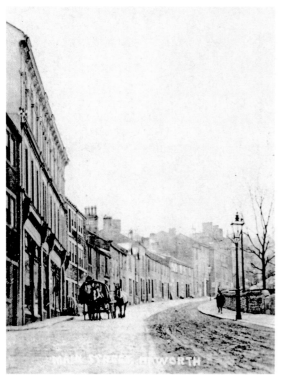

Main Street, c. 1908
It looks as though road works are underway in this picture. Main Street was widened in 1882 but this is probably the re-paving which was done in 1908. Main Street was part of the 1755 Blue Bell Turnpike which ran from Bradford to Colne. Much earlier it formed part of the mediaeval Clitheroegate. This connected the Honours of Pontefract and Clitheroe; the great estates of the De Lacy family on either side of the Pennines.

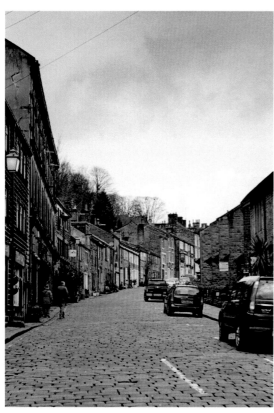

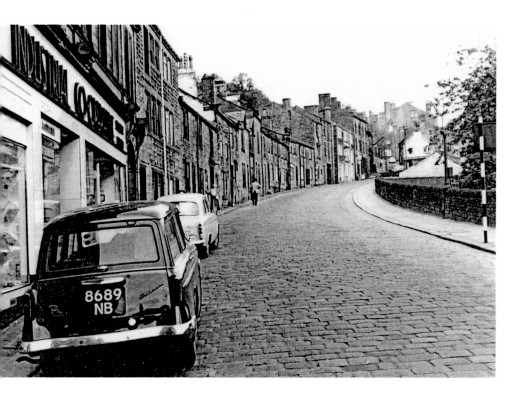

Main Street, Co-op, 1963

After Ogden's house and its neighbours were built in the 1900s there was no further development of that area until about 1990 when a number of new houses were built – seen here on the right. The main co-op store was to close within ten years of this photograph's date. The building is now occupied by a variety of shops and flats. The survival of Main Street's setts is well displayed in this pair of pictures.

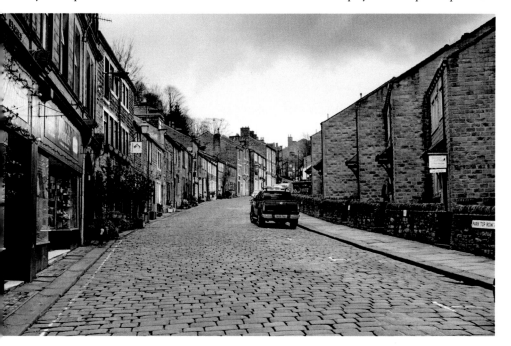

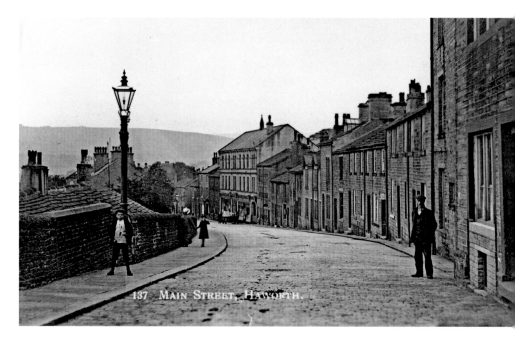

Main Street, c. 1910

Looking down the street from the Fleece Inn the predominantly nineteenth-century character of much of Main Street is apparent. Most of these houses date from the first half of the century. The three storey building immediately above the co-op is perhaps the oldest building in this view. Once home to West Parker's 'Hospital for Umbrellas' and now a restaurant it is one of the best buildings in Main Street and was built around 1800.

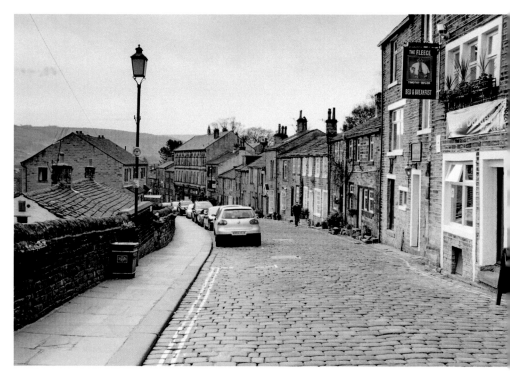

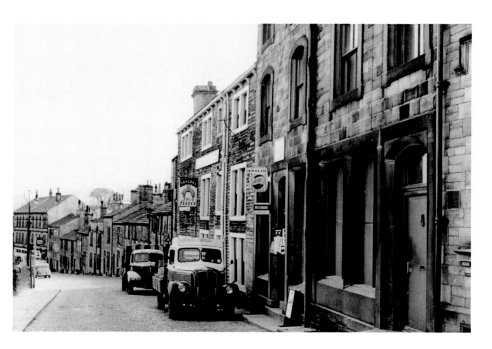

Fleece Inn, 1963

The Fleece appears in the trade directories from 1822 when White's was the first directory to have an entry for Haworth. The building is probably of about that period and it is likely that the inn owes its existence to the turnpiking of the road in the mid-eighteenth century. It was here that the Keighley poet and showman Bill o'th' Hoylus End displayed 'The Great South American War Pig' in 1853.

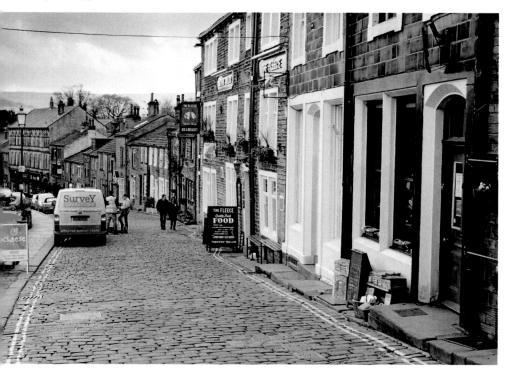

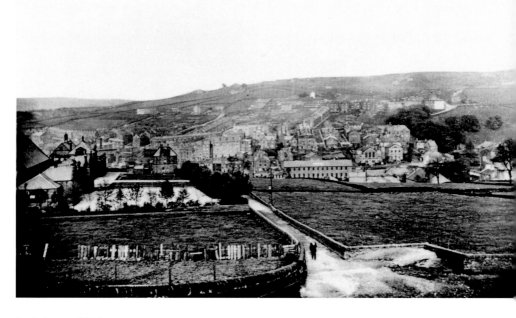

Butt Lane, 1921

Butt Lane now connects Main Street directly with the railway station but it used to take a different line. Before the school was built in 1896 Butt Lane turned left across the school grounds to join Acre Lane which runs down to Mill Hill farm and Lower Mill Hill farm – whose barn occupied what is now the bottom of Butt Lane (see page 25). Note how the park entrance follows the oddly shaped field corner.

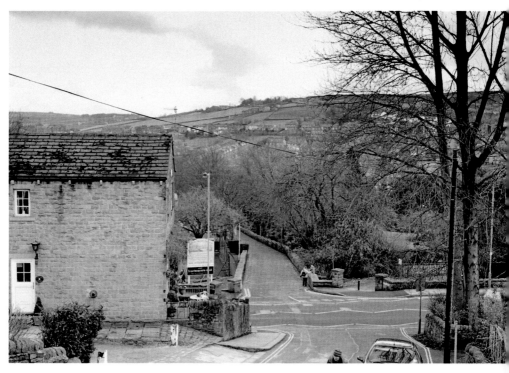

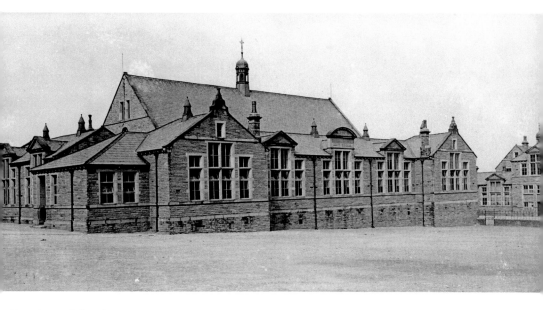

Butt Lane Schools, 1901

This fine photograph of the new Butt Lane Schools accompanied a petition by the children to Andrew Carnegie appealing for his help in providing Haworth with a public library. Owing to strife within the Haworth Council this did not happen – in fact Haworth is still waiting for a library. In the 100 years between the two photographs little had changed; however the main school building has since been converted into housing.

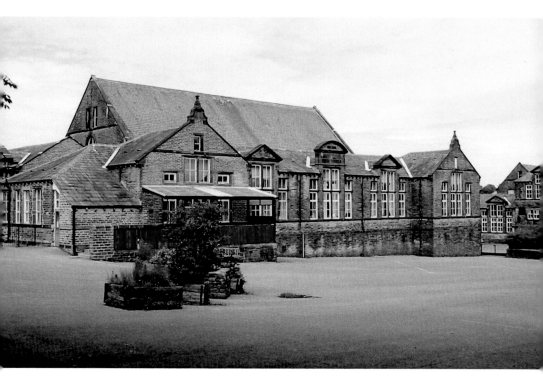

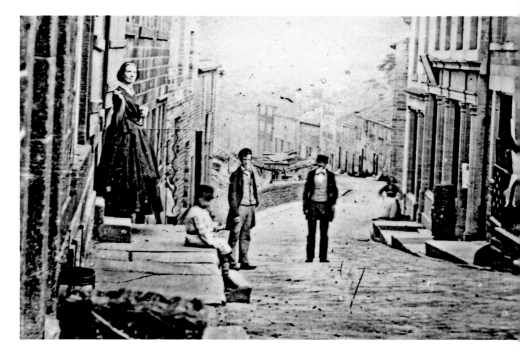

Main Street, c. 1890

An unusually early view of the middle part of Main Street from just above the Fleece. The four houses and old co-op shop which preceded the 1897 co-op building are just visible in the lower part of the street. Between the two men you can see a wood yard. The ashlar double shop front with pilasters dates from 1854. The bystanders' costume is noteworthy.

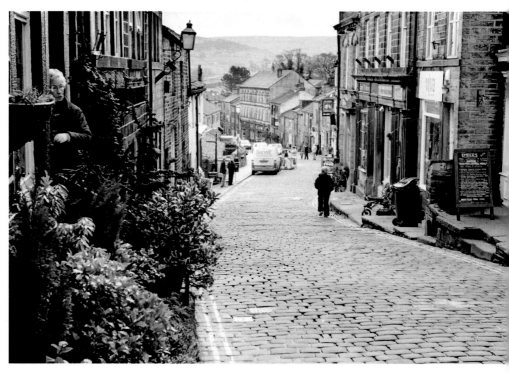

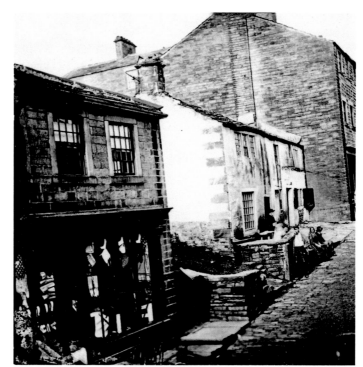

Main Street, 1870s
The draper's shop in the foreground survives with a new extension added but the whitewashed cottages were demolished around 1880. This is a rare photograph of a type of eighteenth-century housing which must once have been common in Haworth but of which little survives in original form. Note the small paned windows and the window shutters above the seated figures. The footpath to the left used to give access to the moor.

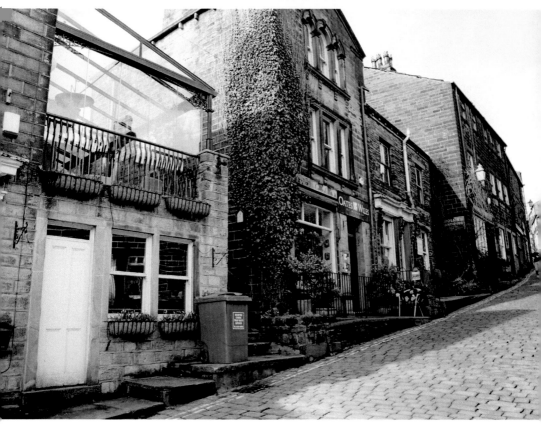

47

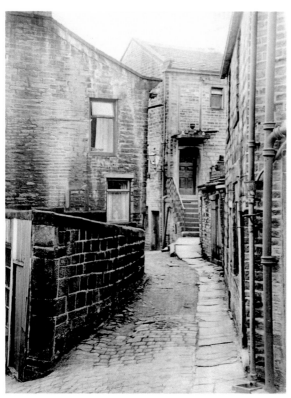

Lodge Street, c. 1960

Formerly called Newell Hill, Lodge Street is a short cul-de-sac off Main Street. The large house with the outside steps belonged to William Wood the joiner. William Wood did many jobs for the Brontë family at the Parsonage. His workshop was on the first floor and the taking-in door can clearly be seen – although it is now blocked. Through this door would have come the coffins which he made for most of the Brontës.

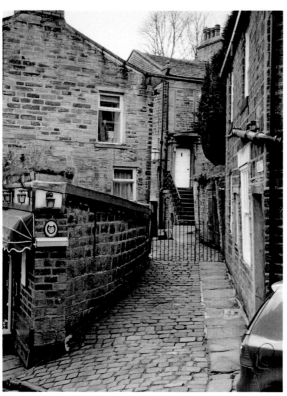

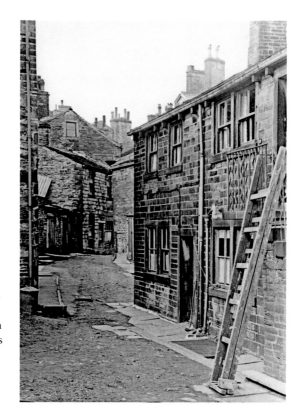

Lodge Street, c. 1960

This view looking along Lodge Street towards Main Street shows the street's other Brontë connection. The house in the foreground was, from 1833, the home of the Three Graces Masonic Lodge of which Branwell Brontë was a member. It was this which gave Lodge Street its present name. The 'Private Rooms' as they were known also housed the Haworth Mechanics' Institute for a few years around 1850.

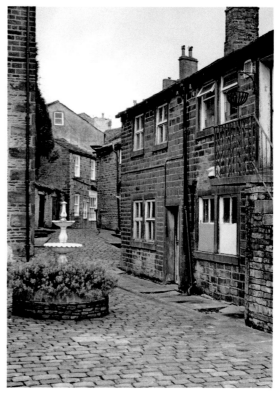

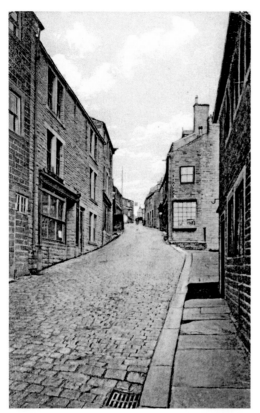

Main Street, early twentieth century
The upper stretch of Main Street with the Yorkshire Penny Bank building (now the Tourist Information Centre) just coming into view. The cottages in the right foreground were demolished in the 1920s. During the second half of the nineteenth century they were occupied by a family of shoemakers called Whitham. The street on the right is Croft Street (formerly Cripple Lane) which led to Gauger's Croft.

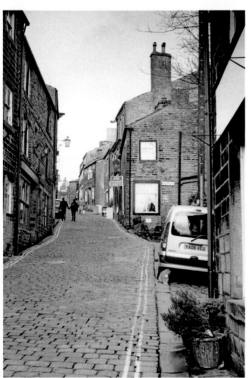

Main Street, c. 1900

There were 13 cordwainers in Haworth in 1901. One was Zachariah Booth whose shop at 87 Main Street is on the left in this picture. He was in business in Main Street from about 1884 to 1936 or later. His trade was generally described as 'clogger' until about 1890 and 'shoe maker' thereafter perhaps reflecting a change in fashions or aspirations. He died in 1945 aged 85 and is buried in the cemetery on Haworth Moor.

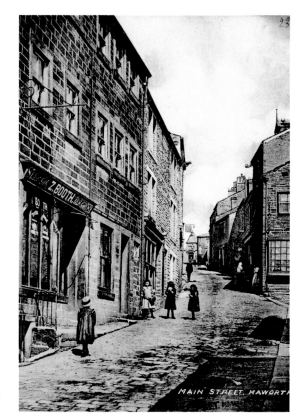

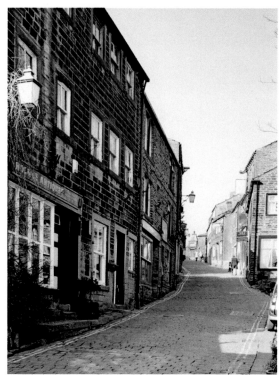

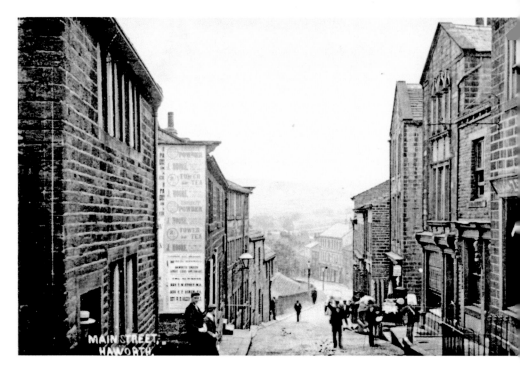

Main Street, c. 1900

A busy Main Street in the early twentieth century. The cottages on the left were demolished in the 1920s (see page 50). The site later provided a useful passing place when buses ran up Main Street. The shop with the posters advertising Insect Powder and Tower Tea was that of John Moore the chemist and printer. Moore was one of Haworth's early photographers and was responsible for a number of the earliest pictures of the village.

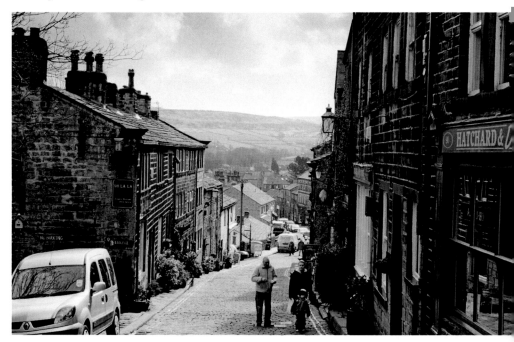

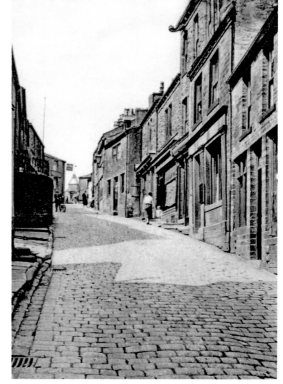

Main Street, 1930s

The three storey building on the right belonged to James Ackroyd who was an auctioneer and house agent. The large pulley at the top of the building was used for getting large items of furniture and the like into and out of his second floor premises. He served as a member of the Haworth council for about fifty years and in 1886 a new gas holder was named Ackroyd's Monument in his honour.

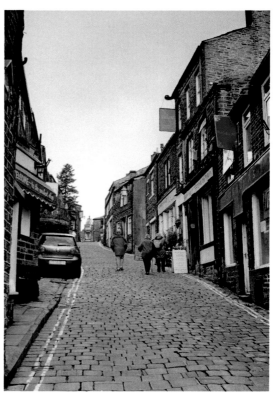

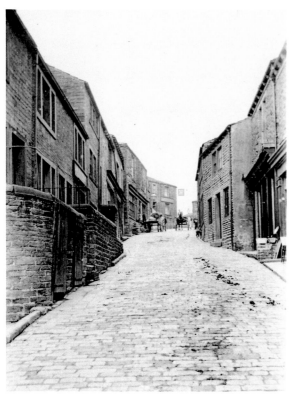

Main Street, 1890s

These pictures of Main Street show how much the character of the street has changed in a century. Most obvious is the change from everyday shops serving the needs of the inhabitants to shops catering principally for tourists. The former were reticent, the latter boldly advertise their presence to the passer-by. The change from horse to motor transport is also indicated by various signs. Note that gas lights are replaced by electric lights of similar design.

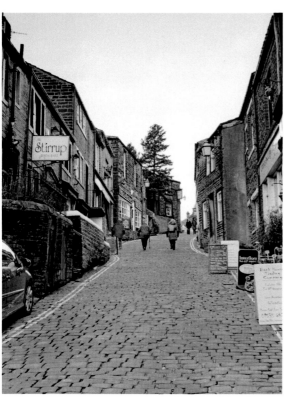

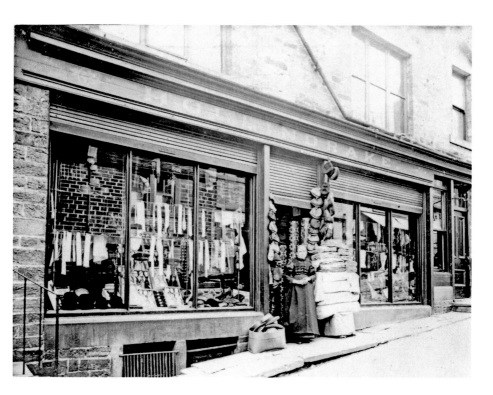

Main Street, 1890s

Manasseh Hollindrake exemplifies Victorian Haworth's fondness for resounding Old Testament names. He ran this draper's shop at 111 Main Street from about 1860 to 1897. He was also a farmer from the 1880s no doubt in connection with his son James's butcher's shop at 66 Main Street. He died in 1919 at the age of 82. The figure at the shop door (in the older photograph) may be his wife Mary who died in 1897.

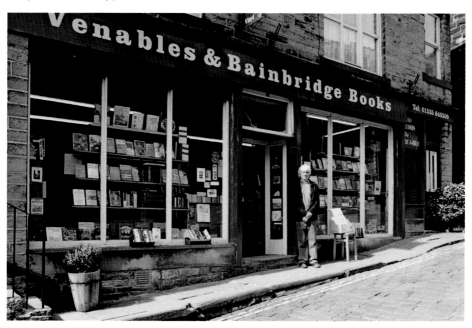

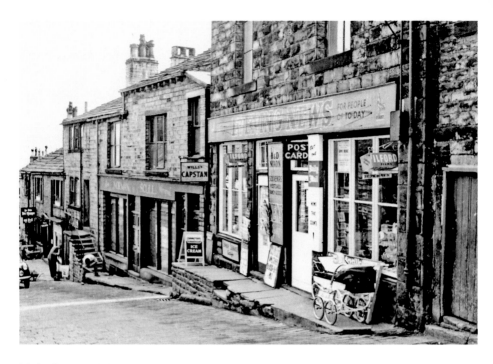

Main Street, 1963

Manasseh Hollindrake was succeeded at No 111 by Albert Henry Scull, a tailor. His son, Norman Scull, took the business over by 1927 and was still there in 1963 when this photograph was taken. Some time later the newsagent's shop moved to Scull's premises and more recently became the second-hand bookshop which it is today. The café occupies the ground floor of the old Liberal Club building.

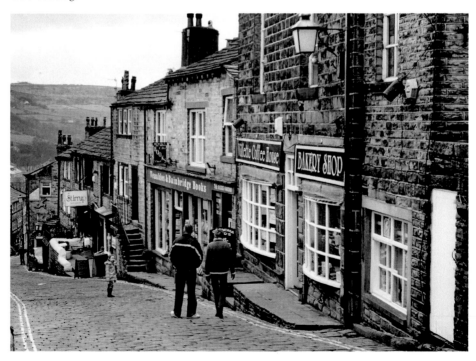

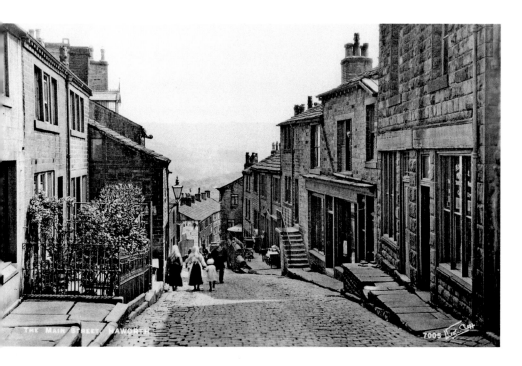

Main Street, c. 1900

The same stretch of Main Street as the previous picture but showing both sides of the street. The two women in shawls are passing James William (son of Manasseh) Hollindrake's butcher's shop. The shop below that had been the wonderfully named Zerubabbel Barraclough's ironmongery shop until his death in 1878. Behind Barraclough's shop was, in the 1850s, Haworth's vagrant office which played a part in the administration of poor relief.

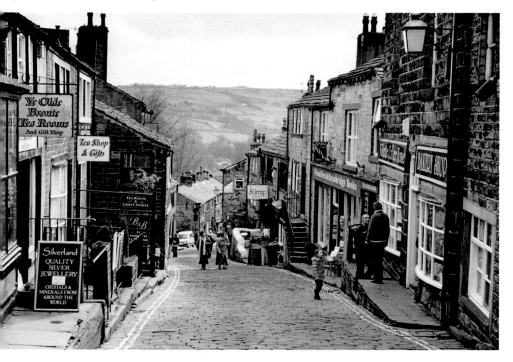

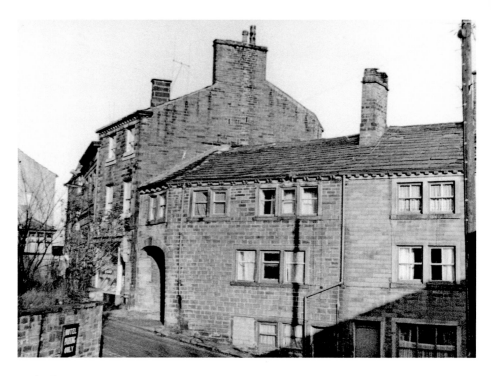

Main Street, 1967

Looking across Main Street from the Black Bull car park we can see the archway which led through to the area of housing called Old Piccadilly. This was also known as Brandy Row and Gauger's Croft. The building through which the archway passes belonged to Richard Roberts Thomas in 1850. His trade as a wine and spirit merchant lies behind the names Brandy Row and Gauger's Croft (a gauger being an excise man).

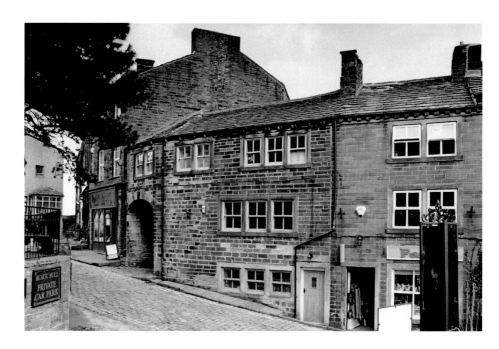

Main Street, *c.* 1900

The Liberal Club was built in 1853 as the Black Bull lecture rooms. At first it was the home of the Haworth Mechanics' Institute which moved here from Lodge Street. They left in 1877 but were to return in 1894 (see pages 49 & 64) In 1881 the building re-opened as the Haworth Liberal Club. The Liberal Club closed in the 1960s since when it has housed a variety of shops.

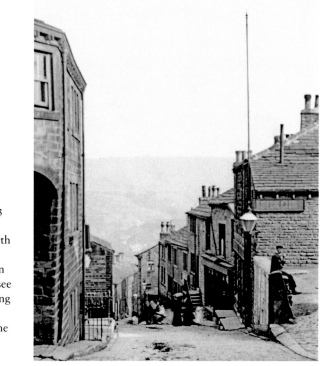

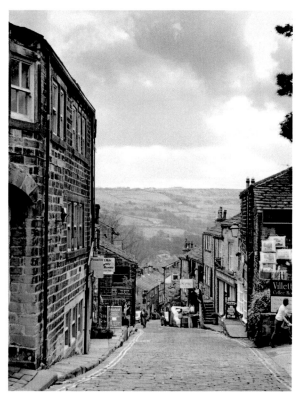

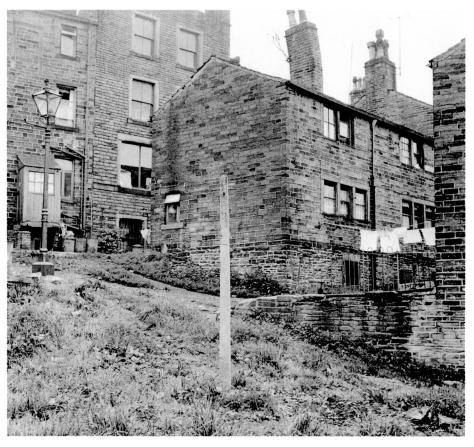

Top Street, 1963

The house with the splendid curved chimney stack is at the end of Top Street in Piccadilly, the tall buildings are on Main Street. The Piccadilly streets – Top, Roper, Mount, Star & Moon – were swept away by Keighley Corporation in the late 1960s in the name of slum clearance – despite the Civic Trust saying that most could be made into perfectly good dwellings. The site became a car park and is now a medical centre.

Main Street, 1926

A last look down Main Street from the Black Bull (note the 'three tuns' pub sign). From here we can see the steps inside the archway (which, oddly, does not seem to have a local name) leading to the upstairs house. Mary Wood of the Bronte Café was advertising her confectionary to tourists in the 1900s (speciality 'Plum, Seed & Madeira Cakes'). Under the Murgatroyds it was still advertising in guide books half a century later.

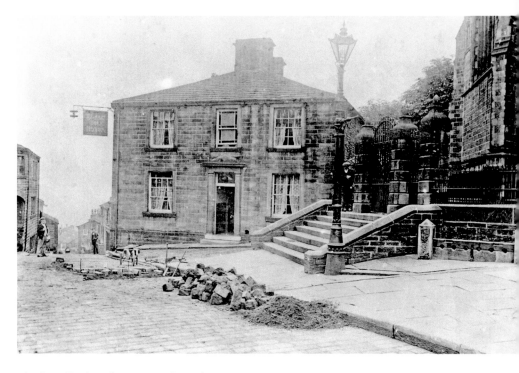

Black Bull, church steps and stocks, 1910

The Black Bull seems little changed by the passage of a hundred years – apart from the porch, the new windows and pub sign. It was long the main hotel for visitors drawn to Haworth by the fame of the Brontë sisters. Rather surprisingly Max Beerbohm took lunch here with Thomas Hardy's widow in 1931. The splendid gas lantern disguises a sewer vent, the stocks were set here in 1909.

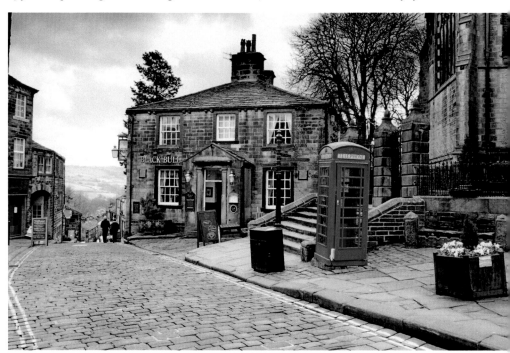

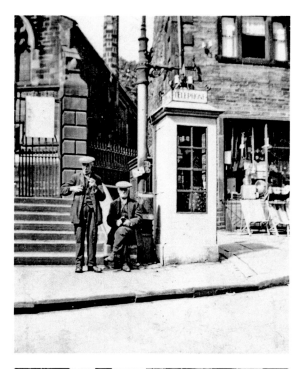

Main Street, 1933

Albert Smith & Tom Parker take their ease by the fine 1920s K1 Mk 236 telephone box (its replacement is Giles Gilbert Scott's K6 of 1936). In the background is Hartley's hardware shop. This (despite a number of claims to the contrary) was Haworth's post office throughout the Brontës' writing careers and William Hartley was the postmaster. The shop now sells books and gifts but is still in the Hartley family.

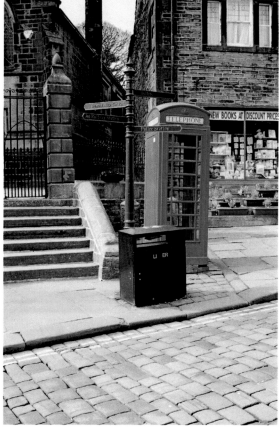

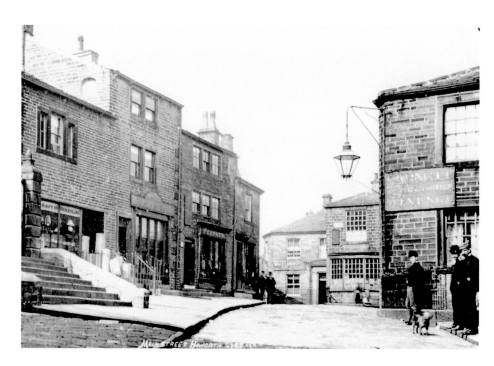

Main Street, 1893

This photograph can be dated to 1893-4 by Anne Lee's name on the White Lion. Right of the Lion is the bow-windowed frontage of the Mechanics' Institute. The Mechanics moved here from the Liberal Club in 1877 (see page 59), in 1894 the Yorkshire Penny Bank bought the building from them and converted it to what we see today. The Mechanics moved back to the Liberal Club and stayed there until 1925 when they closed.

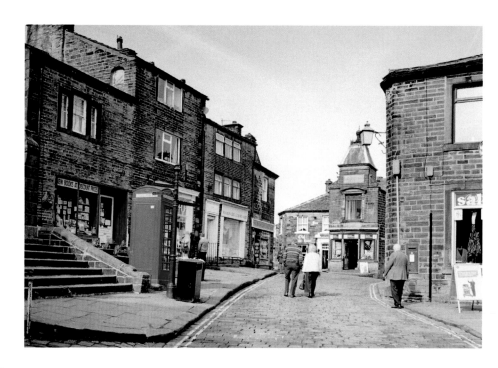

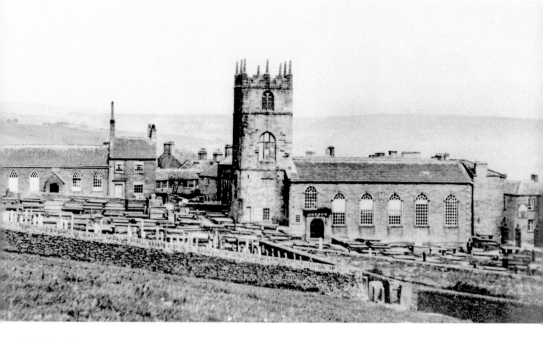

Old Church, 1860s

On the left is the Sunday School which was built by Patrick Brontë in 1832 and extended in 1851. On the right hand side of the Sunday School is Sexton House, built by John Brown in 1838. The gravestones nearest to the camera are quite new – this section of the graveyard was opened in 1856. The tower is ancient but the rest of the old church was built in 1755 – the new church opened in 1881.

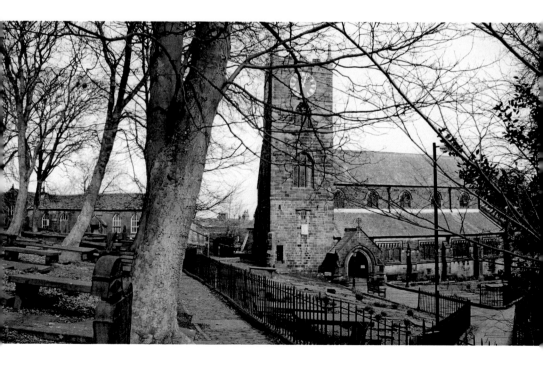

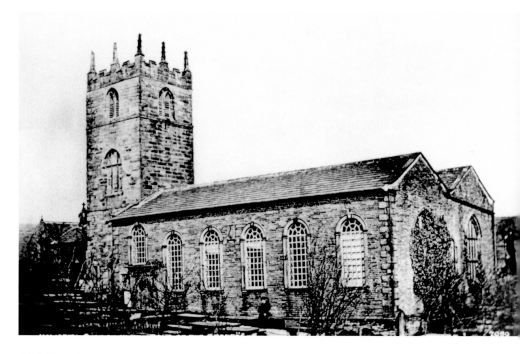

Old Church, 1870s

This photograph gives a good impression of the church of Brontë's day. It was, however, taken in the 1870s after the tower had been raised to accommodate a new clock. Brian Wilks has shown that it was 'doctored' to remove the newer additions. The trees in the churchyard were planted in 1864. There were exaggerated claims for the antiquity of the old church but, apart from the tower, it dated only to Grimshaw's rebuilding of 1755.

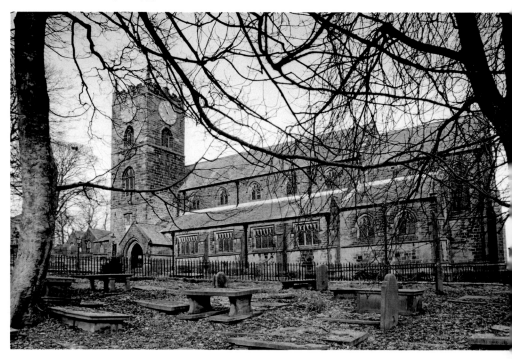

King's Arms, 1916

The King's Arms is a handsome building of the mid-eighteenth century – although a small part of the building near the Fold belongs to the seventeenth century. It was used from 1763 (or possibly a little earlier) as the meeting place for the manorial court. From 1768 it is referred to in the manor court rolls as the "Manor House of Haworth." It is last mentioned in this connection in 1870.

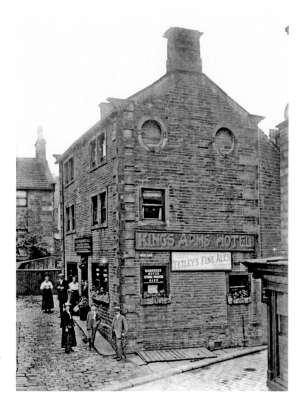

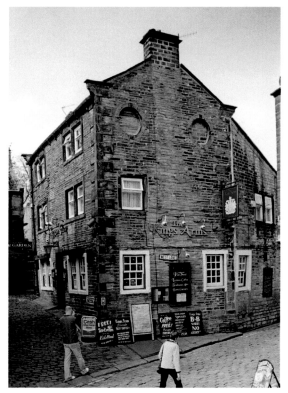

Church Street, c. 1930

These are the backs of some of the shops at the top of Main Street seen from Church Street. They are early nineteenth century in date – although the three light window on the right could be a little earlier. The removal of railings during the war – except where needed for safety – is apparent. The approach to the house door up the roof of an outhouse is particularly striking in the old photograph.

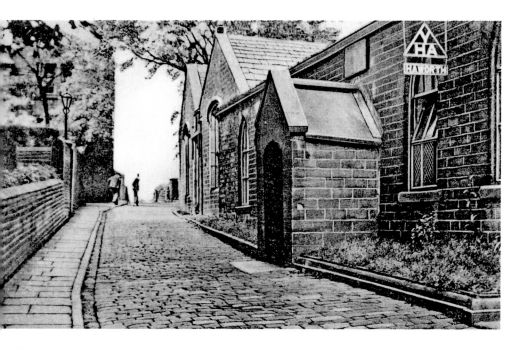

Church Street, Youth Hostel, 1950s

Patrick Brontë's old Sunday & National School building of 1832 has two additions at the far end. The first gable was built in 1851 and the second in 1871. A new Sunday School was built behind this one in 1900 in what is now the Parsonage Museum car park. The Haworth Youth Hostel was here from 1950 to 1958. The present YHA, Longlands at Lees opened in 1976.

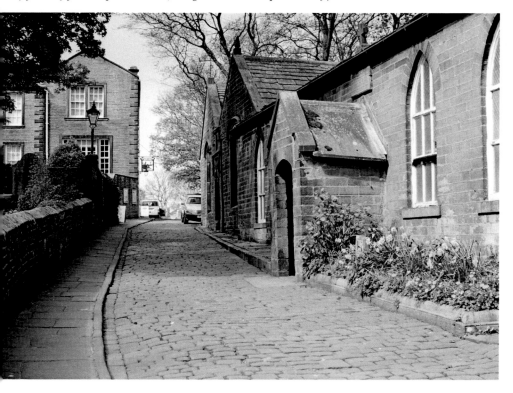

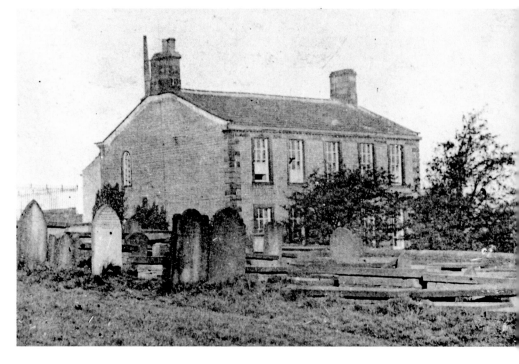

Old Parsonage, c. 1860

Almost certainly the most photographed building in Haworth is the parsonage made famous by the Brontë family. It was built by John Richardson in 1779 as a more convenient home for the minister than Grimshaw's Sowdens Farm. Brontë came here in 1820 and stayed until his death in 1861. Brontë's successor John Wade added the new wing on the right in 1878. The parsonage became the home of the Brontë Society's museum in 1928.

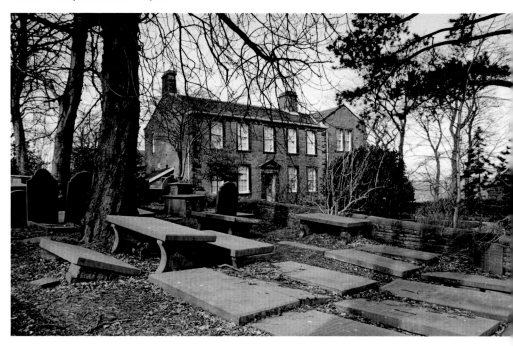

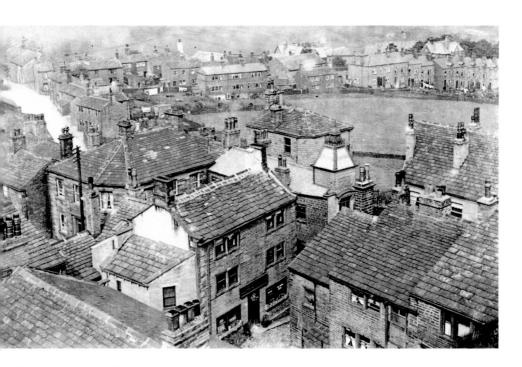

Church Street & Changegate from Church Tower, 1916

Every Haworth photographer who has the opportunity climbs the steps and ladder to the top of the Church tower for the views that it affords over the village. The tower itself and the trees in the churchyard direct his attention to the north. The effects of slum clearance and new road building are very apparent in these two views from the tower. Note the re-roofing of the King's Arms.

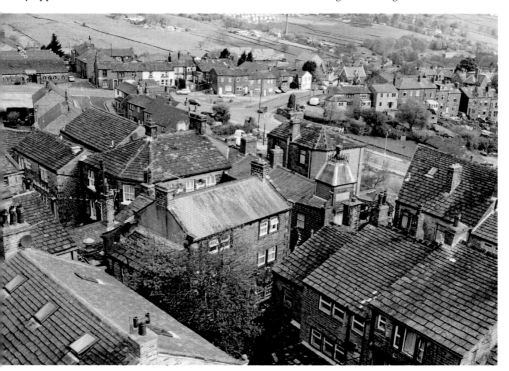

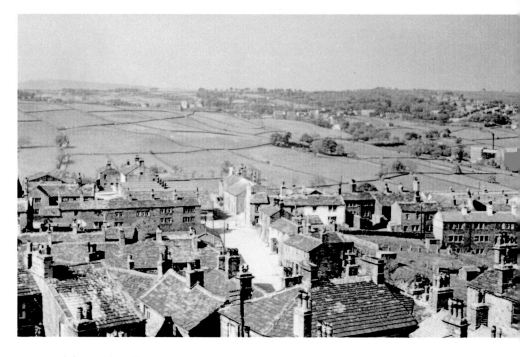

Townend from Church Tower, 1960s

Well Street, Hird Street and part of North Street were demolished in 1968, their place being taken by the car park. This leaves a clearer view of Townend Farm and Rushworth Lund's weaving sheds – now a mill shop. To the right, houses were cleared to make way for the widening of Mytholmes Lane and the construction of Rawdon Road. New houses are being built in place of Ashmount Mill in the later photograph.

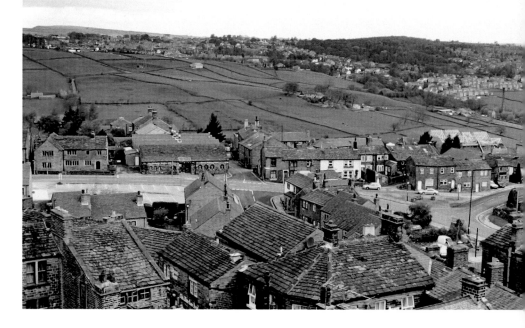

Changegate, 1967

All but two of the old cottages on this side of Changegate were knocked down in 1968. The cottages in the foreground have made way for a small car park for the White Lion hotel. In 1901 the shop (second from left) was John Ogden's butcher's shop. From at least the 1940s it was a private house, not a shop. On the right of the new photograph is some of the new housing which has replaced Well Street and Hird Street.

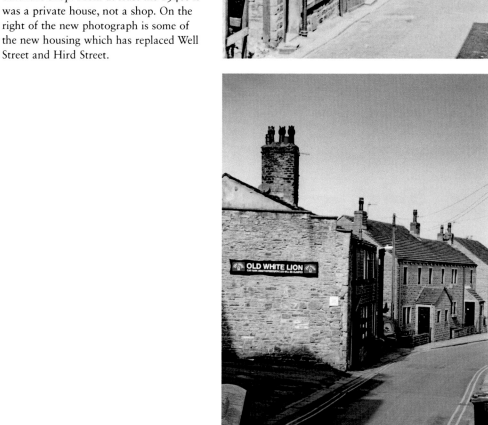

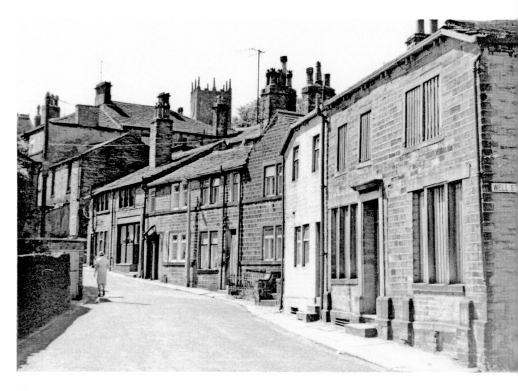

Changegate, 1967

Here is the same stretch of Changegate seen from the other end. The end of Well Street can be seen front right. The entrance to Hird Street is hidden behind the light coloured house (second from right). 17 Changegate, to the right of the lamp post, was the home of John Wood. He was a cabinet maker and a grandson of William Wood (see page 49).

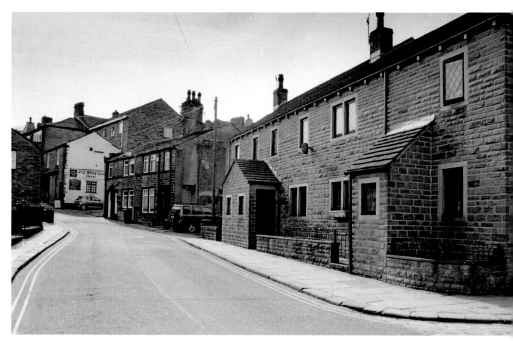

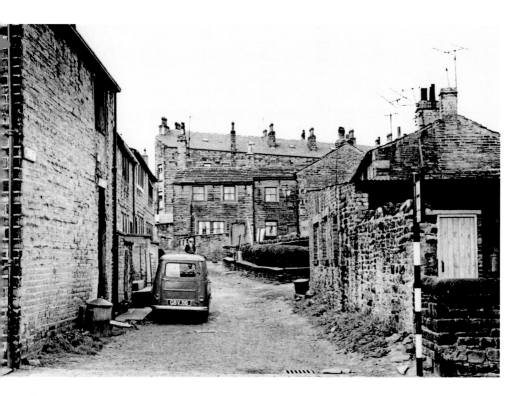

Well Street, 1963

Well Street was another casualty of clearance mania. The name comes from three large stone water troughs which used to be there. This Head Well was the main source of water supply for the upper part of the village in the first half of the nineteenth century. It was inadequate – people had to queue up from two in the morning to get water – and was sometimes so foul that cattle refused to drink from it.

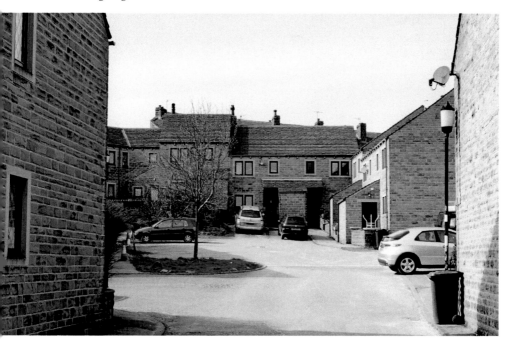

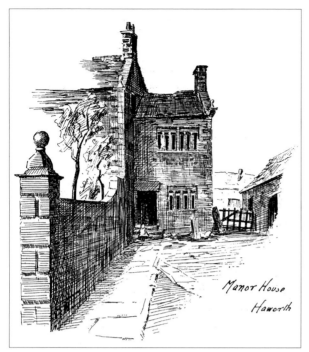

Manor House, Haworth

Manor House, Cookgate, 1899

The main part of Cookgate Manor (to the left) is a Georgian house rather similar in appearance to the parsonage. The cottage on the end is what remains of the earlier, seventeenth century manor house. The farm buildings on the right were also seventeenth century. The house is little altered apart from the sad mutilation of the mullioned windows.

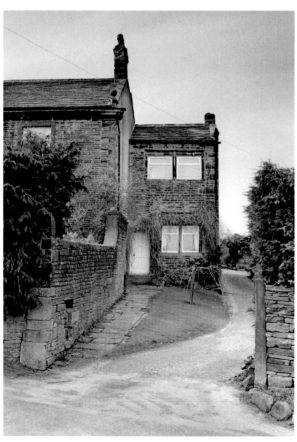

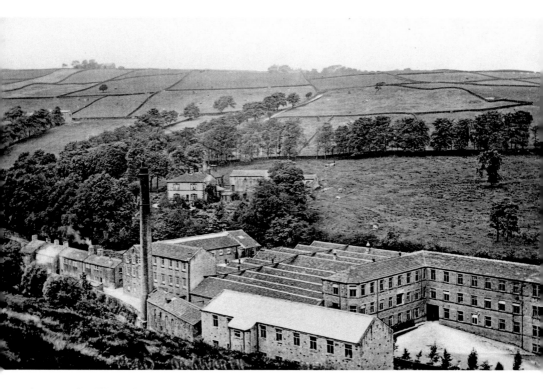

Spring Head Mill, early 1900s

In the Worth Valley between Haworth and Oakworth is Springhead Mill. The mill was one of three in the area run by the firm of Hattersley, Sons & Co. On the right is a three storey spinning mill with weaving sheds to the left. The mill chimney rises at the end of the boiler house and engine house. A second spinning mill is behind the chimney and the mill owner's house behind that.

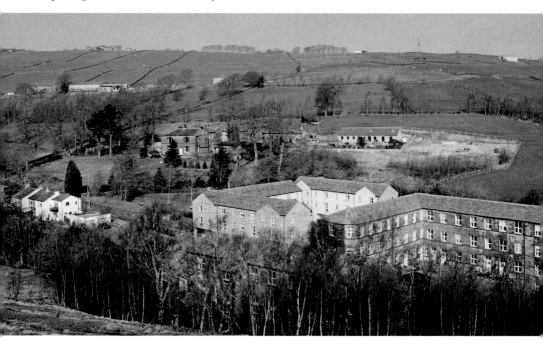

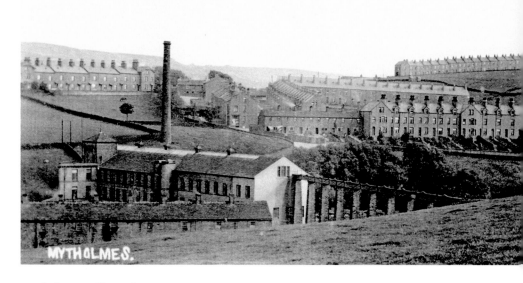

Mytholmes Mill, early 1900s

Mytholmes was another of the Hattersley mills in the Worth Valley. The trough and chimney show that both steam and water power were used, the water wheel was removed in 1908. Most of the housing in this picture was built by the firm for their workers between 1835 and 1899. There were also a co-op, other shops, canteen, bath house, tennis courts, bowling green and a mission chapel. Mytholmes was effectively a self-contained mill village.

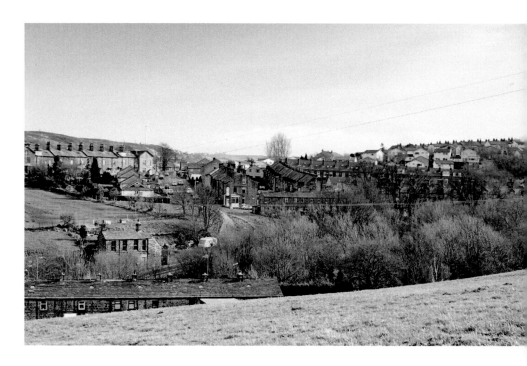

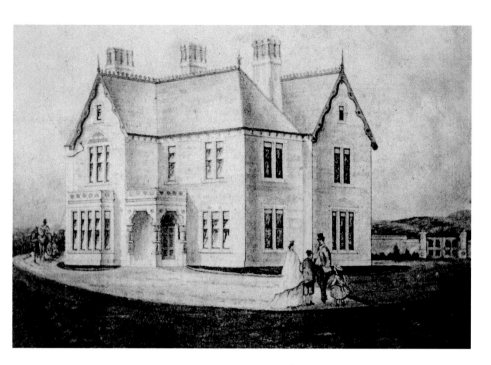

Ashmount, c. 1870

Many large villas were built in the area in the later nineteenth century by mill owners and professional people. Ashmount was built by Haworth doctor Amos Ingham in 1870. It clearly made a great impression as it was the only private house described at length in the accounts of Haworth in the trade directories. The quality of the stone carving was particularly mentioned as were the carved heads of the twelve Apostles which adorned the garden.

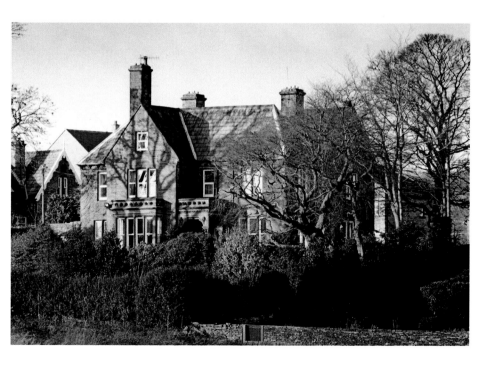

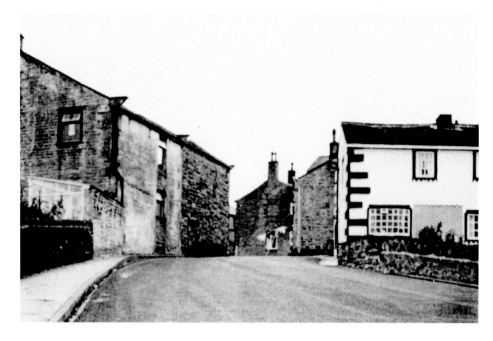

Townend Bottom, 1960s

The destruction by fire of Mytholmes Mill in 1966 opened the way for the widening of the Mytholmes Lane route to Oakworth. This involved the demolition of the mill and of other properties in Mytholmes Lane and North Street. Around the same time Rawdon Road was built to bypass Main Street. The farmhouse on the left at Townend Bottom was one of the more significant buildings to go.

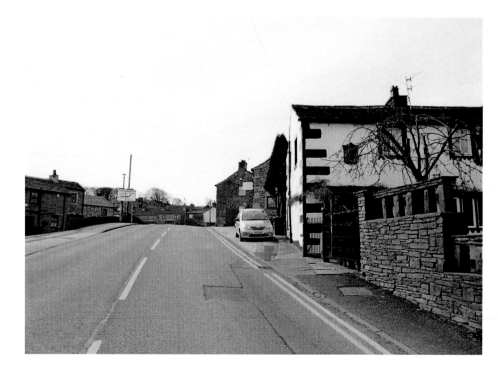

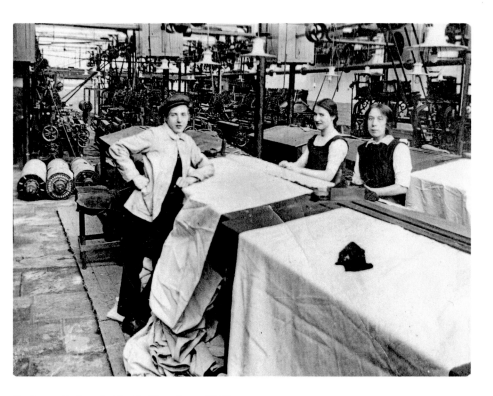

Rushworth Lund, North Street, _c_. 1930

A mill hand talks to two burlers and menders at Rushworth Lund's small worsted mill. Behind them are the looms on which this cloth was woven. Overhead is the line shafting bringing power to the looms. The power source was probably a gas engine as there was no mill chimney and therefore no boiler house for steam generation. A mill shop now occupies these sheds – and Townend Farm barn behind which they lie.

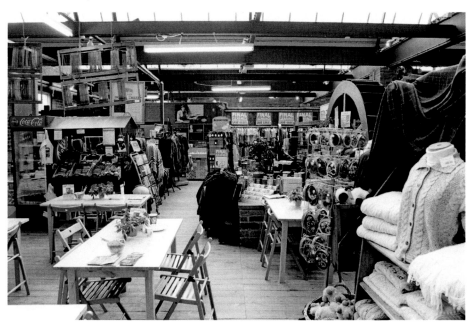

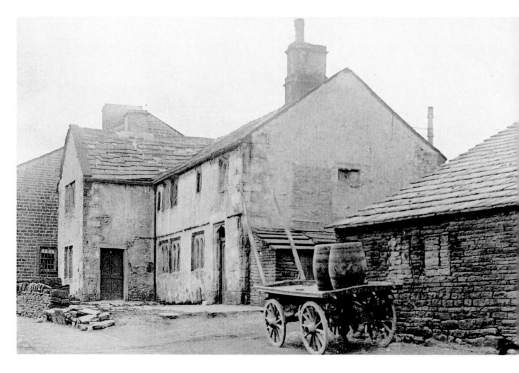

Townend Farm, c. 1900

Townend Farm is Haworth's other fine seventeenth-century building (see page 30). Built about 1600 it is built to an uncommon plan mostly found in the Burnley area. It was amongst the properties which were bought by the Emmott family in 1749. The barn on the right is that which formed part of Rushworth Lund's mill (see page 81). The cart is a reminder that Willie Binns who farmed here in the early twentieth century was also a carrier.

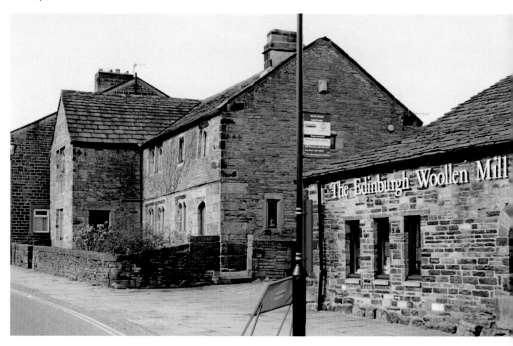

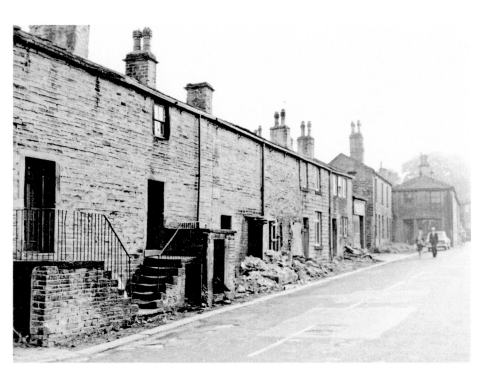

North Street, 1968

Across the road from Townend Farm these houses are pictured just before demolition in 1968. The steps to the first two houses incorporate coal sheds. The other outbuilding was a shared toilet. Further up the street the outbuildings have already been demolished. The tiny shop just before the gap was originally Haworth's lock-up. It is first mentioned in 1839 when William Eccles was ordered to remove 'the building he had erected against the Public Prison of Haworth'.

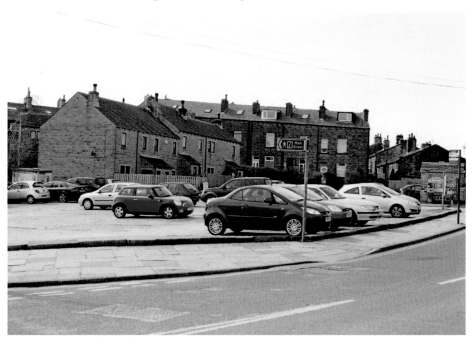

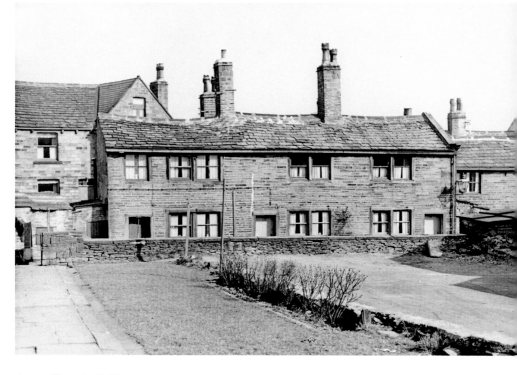

Acton Street, 1960

Behind the demolished houses on North Street lay Acton Street which is photographed here from West Lane. To number 6 at the right of the row "mony a fooil fra Keighlee come / To hear his fortune read" for this was the home of Old Jack Kay the village wise man. As well as telling fortunes he was reputed to foretell and even control the weather and defeat the evil wrought by witches.

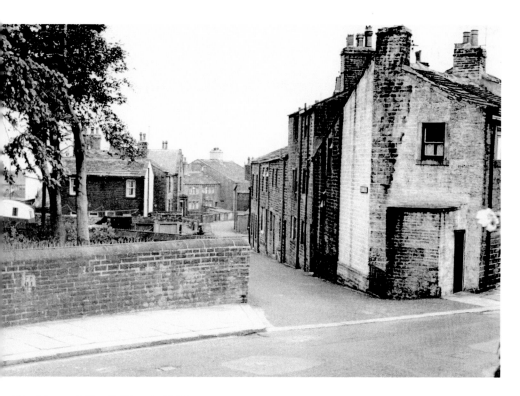

West Lane / North Street, 1963

This striking bottle neck at the junction of North Street and West Lane was the tightest of those cleared in the road improvements of the early 1970s. It was originally proposed to knock down the houses on the right but the occupants were unenthusiastic. Instead the dead were evicted – a section of the West Lane Baptist burial ground on the left was removed to make way for the road.

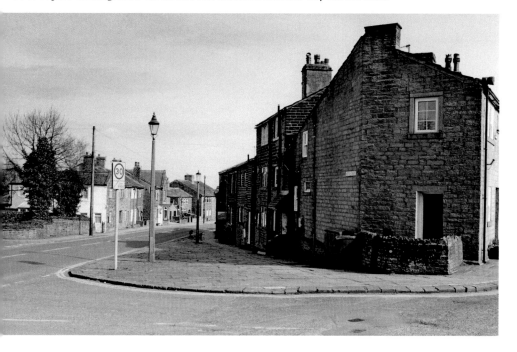

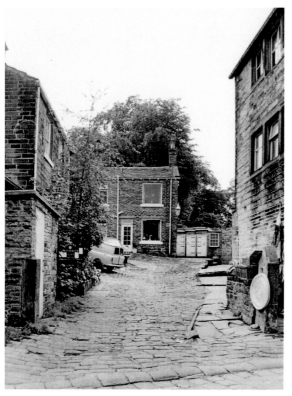

The Fold, c. 1970

Folds – groups of houses arranged around an open space – are a feature of Pennine towns. Haworth's Fold lies just off West Lane near the King's Arms. The houses on either side are early nineteenth century but those at the far end were built in 1877. In 1850 there was a single privy in the Fold that was used by eight families. This was not exceptional; in other parts of Haworth 24 families shared one privy.

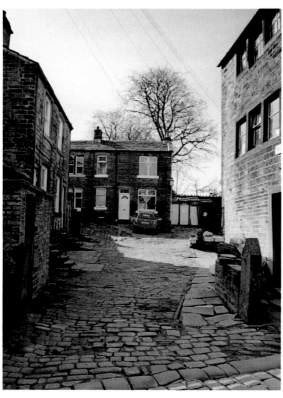

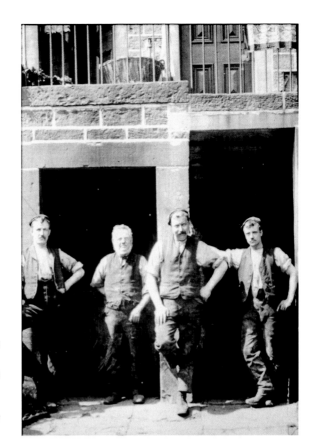

Smithy in The Fold, c. 1900

Abraham Scarborough worked as a blacksmith at this smithy in the Fold from the 1860s. He was followed in the trade by his son Herbert. They are seen here outside their smithy with two other smiths. Our new photograph is framed to show the whole arrangement of the two houses above the smithy approached by stairs and a balcony. What was the blacksmith's shop is now largely occupied by a garage.

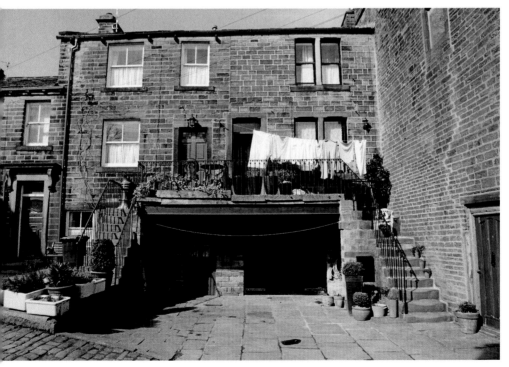

West Lane, 1963

The frontage of the Toby Jug café is now hidden behind an extension which forms the entrance to Weavers restaurant. The houses immediately beyond this are good examples of early nineteenth century houses with cellar dwellings under them. On the right hand side of West Lane are the later houses of Bronte Street and Ingestre Street.

Well Street / West Lane, 1963

This splendid gas lamp stood at the top of the narrow lane which connected Well Street and Hird Street with West Lane. The row of houses is the back of the Well Street Fold (the other side of these houses can be seen behind the clothes post on page 75). For some reason these houses were demolished before the rest of the Well Street area. They had already gone by 1965.

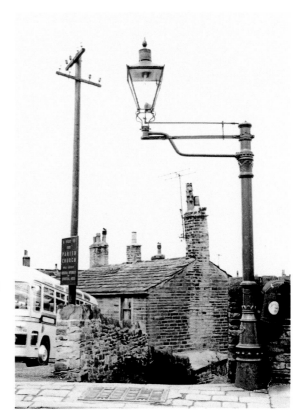

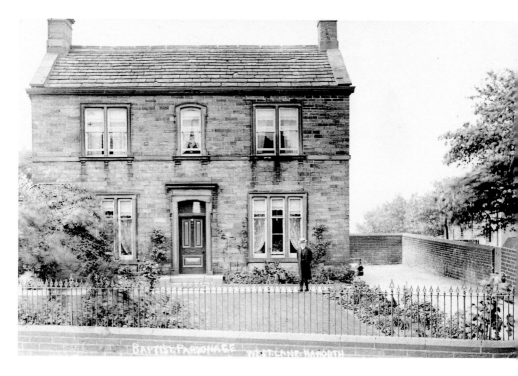

West Lane, Baptist Parsonage, c. 1906

The Baptists first established a chapel in Haworth in 1752 but it was not until 1860 that they built this manse for the minister. The first occupant was the Rev J.H. Wood, the man in our photograph is David Arthur who had a 'long and fragrant ministry' from 1889 to 1928. His successor Chris Upton demonstrates the changing fashions (and pushchairs) amongst Baptist Ministers over the past century.

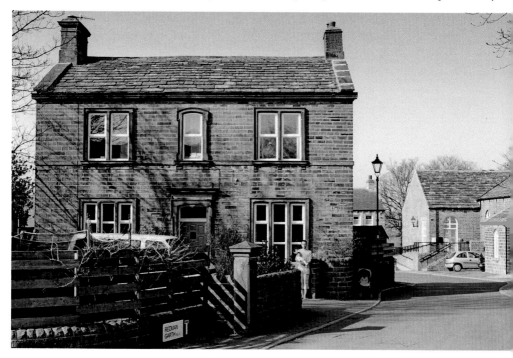

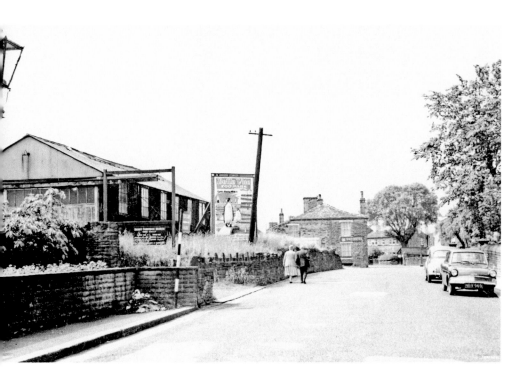

West Lane, Navvies' Mission, 1963

The building on the left was opened in May 1916 as a Mission Hall for the navvies working on the new Lower Laithe reservoir at Stanbury. The opening was conducted by the Mayor of Keighley with the support of Ratcliffe Barnett (the reservoir engineer), the rector of Haworth and other local Anglican clergy. In the distance is the Sun Inn, the garage to its right is on the site of Haworth's pinfold where stray animals were impounded.

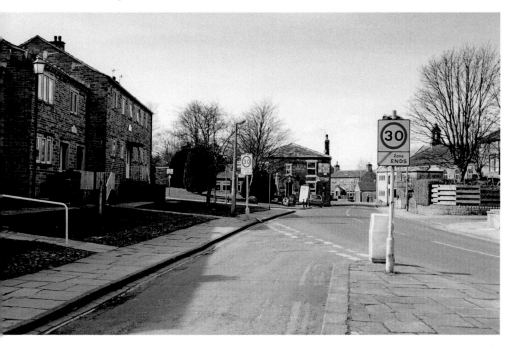

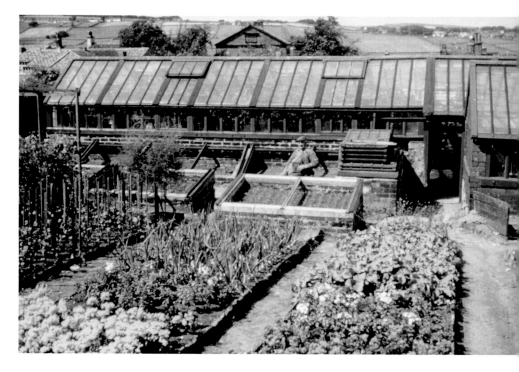

Allotment, c. 1970

Norman Inman enjoys a summer's day at his allotment off West Lane. Allotments first appeared in Haworth during the 1914-18 war. By the time that this photograph was taken there were something like a dozen plots of land devoted to allotment gardens in Haworth. There are now only three and demand is such that there is a waiting list. Even those that remain are not inviolable – the demands of development may still threaten them.

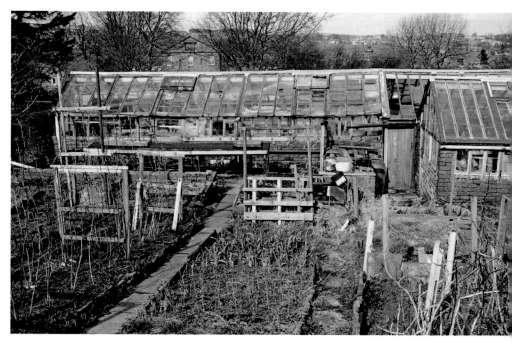

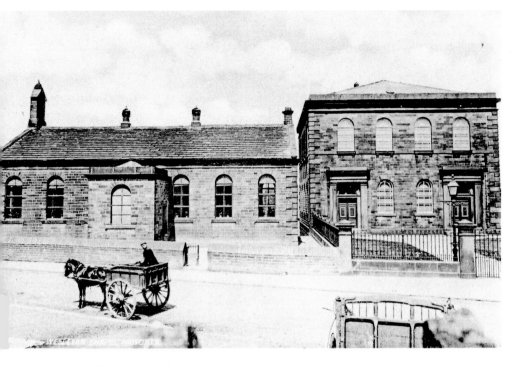

West Lane Wesleyan Chapel, c. 1895

William Grimshaw built the first Methodist Chapel on this site in 1758. Various enlargements and rebuildings followed. The Chapel on the right in this photograph was built in 1845 and demolished in 1951. The Sunday School (on the left) now serves as the chapel. It is often said that this building dates from 1830 but it is more likely that it was completely rebuilt in 1853.

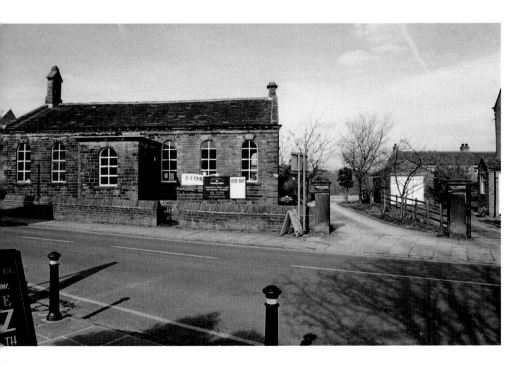

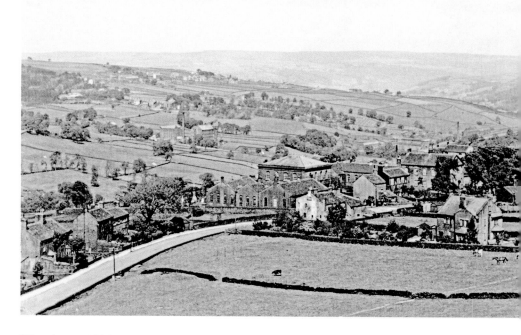

West Lane, 1930s

A view along West Lane towards the village taken from the edge of Penistone Hill. The narrow field strips in the right foreground are probably part of the mediaeval arable land of Haworth. The large detached house in the strip with trees and shrubs is the new rectory which has housed Haworth's rectors since the old parsonage opened as the Bronte Society's museum in 1928.

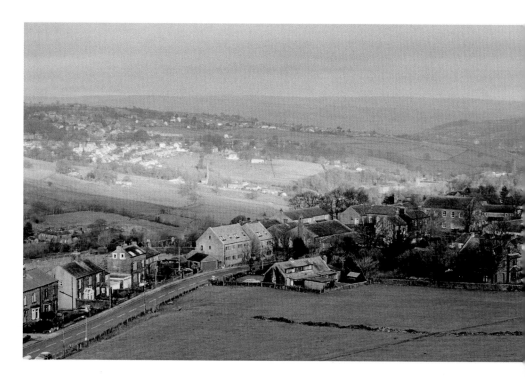

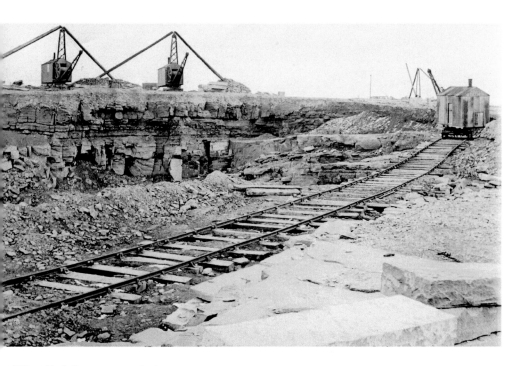

West End Quarry, c. 1910

Apart from textiles, stone quarrying was one of Haworth's main industries. There are good building stones, flagstones and even roofing stone to be found in the millstone grit. West End quarry was one of four major quarries on Penistone Hill. Large blocks of stone were lifted out of the quarry by the fixed and travelling cranes seen here. The quarry, like nearly all those in the area, is now partially filled in and largely overgrown.

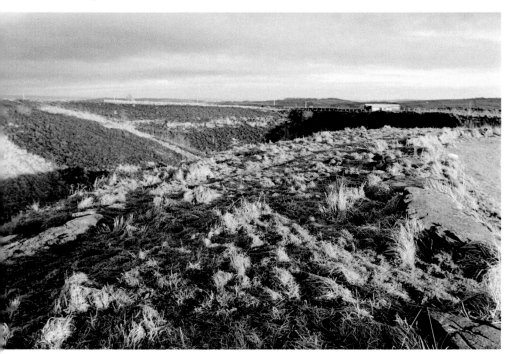

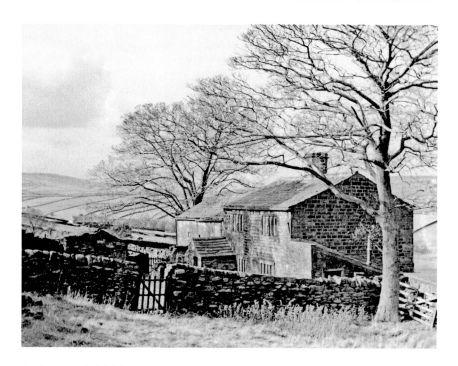

Springs, Enfleldside, 1964

The third industry of the Worth Valley was, of course, farming. The farms were mostly very small dairy farms. Springs had mistals for a few cows, ran sheep on the moors and probably had a pig or two and some hens. It was difficult to keep a family on the produce of a small farm like this and most farmers would also be wool combers or weavers or, as at Springs, stone masons.

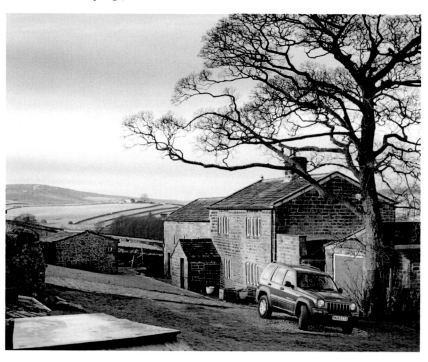